BUXTON
THROUGH TIME
Alan Roberts

AMBERLEY PUBLISHING

First published 2012

Amberley Publishing
The Hill, Stroud
Gloucestershire, GL5 4EP

www.amberley-books.com

Copyright © Alan Roberts, 2012

The right of Alan Roberts to be identified as the
Author of this work has been asserted in accordance
with the Copyrights, Designs and Patents Act 1988.

ISBN 978 1 4456 0817 4

British Library Cataloguing in Publication Data.
A catalogue record for this book is available from
the British Library.

Typeset in 9.5pt on 12pt Celeste.
Typesetting by Amberley Publishing.
Printed in the UK.

Introduction

Buxton is situated on the Derbyshire Wye, in the Peak District. With the source of the Wye 2 miles away at 1,800 feet, the town centre is at about 1,000 feet, making it one of the highest towns in England. Here, the Wye flows in a narrow valley along the boundary between the limestone plateau of the White Peak and the gritstone hills of the Dark Peak.

The key feature in the development of Buxton from a small isolated village to a town of more than 20,000 people was the existence of mineral water springs in the valley close to the Wye. These springs were known to the Romans and healing powers were attributed to the springs during the medieval period. Their fame began to grow when Buxton Hall was built adjacent to the springs for the Earl of Shrewsbury in 1572.

At that time, apart from the two or three buildings near to the springs, Buxton was on the high ground, around the present-day market place area. Similarly, the neighbouring village of Fairfield was located on the high ground on the other side of the Wye valley.

In the 1780s, the magnificent Crescent was constructed for the Duke of Devonshire adjacent to Buxton Hall, and town houses, apartments, shops, spa facilities, a theatre and other entertainment facilities followed as the fashionable Georgian scene came to town.

The present layout of the town developed around roads built as turnpikes, which reduced Buxton's isolation by providing links to Manchester (1724), Sheffield (1759), Macclesfield (1759) and Leek (1765). These roads followed traditional routes across the hills but the 1810 turnpike from Buxton to Ashford broke new ground by cutting along the Wye valley into Buxton. A new Macclesfield road was built in 1821 (St John's Road) with easier gradients across the hills.

The town continued to develop during Victoria's reign and a boost to the town's growth came in 1863 with the arrival of railway connections

to London and to Manchester, with two adjacent stations close to the town centre. Several large hotels and hydropathic establishments were constructed as well as many spacious villas set in large plots and the town expanded out from the narrow valley. Spring Gardens developed as the main shopping street. The large stable block built for the Crescent was used as a hospital and in 1881 the stable yard was covered by the large domed roof that is another prominent landmark of Buxton.

Entertainment facilities increased with the opening of the Pavilion Gardens, which by 1875 had 23 acres of landscaped park and a range of concert halls, a ballroom and a theatre. This was followed by the opening of the Opera House in 1903. Extensive tree planting took place on the hills closest to the town and these areas are now mature woodlands forming an attractive backdrop to the town.

These factors left a wealth of buildings related to the spa's development grouped together in the centre of Buxton, to such an extent that the Wye is covered over for much of its passage through the town, with other residential and commercial parts of the town on the higher ground. A period of retrenchment in the post-war period saw the closure of one railway station, several large hotels and two cinemas. However, the station closure gave the opportunity for the construction of Station Road as a relief road for Spring Gardens, which was then pedestrianised, and the Spring Gardens Shopping Centre was built on neglected ground behind the existing shops.

Through all of these changes, Buxton has remained an important centre for exploring the many and varied attractions of the Peak District. In addition, the reopening of the Opera House as a theatre in 1979 and the creation of the Buxton Opera Festival contributed to the re-emergence of the town as an attractive place for visitors and residents alike. The twenty-first century has already seen the development of a campus of the University of Derby, the construction of a major science research facility, the opening of the Pavilion Arts Centre, a makeover of the Pavilion Gardens and the construction of a large new bottling plant for Buxton Mineral Water. The Crescent has been unused for many years during the planning of a complex restoration project but now building work has started for the project.

What will follow in the journey of Buxton through time?

Alan Roberts

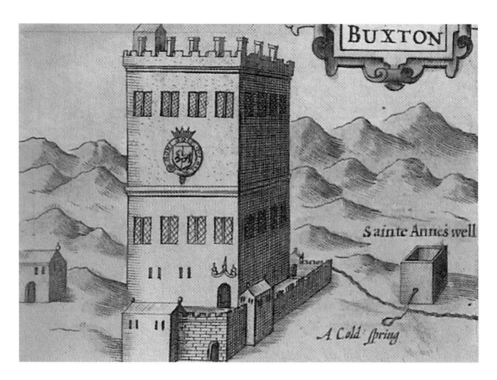

Buxton Hall

Buxton Hall was built in the 1570s for the Earl of Shrewsbury, who was at that time the custodian of Mary Queen of Scots during her period of imprisonment. Buxton Hall was located on the banks of the Wye, adjacent to the mineral water springs known as St Anne's Well, which were famed for their therapeutic properties. Mary stayed at Buxton Hall for several weeks during 1576–1578, seeking treatment for her rheumatism.

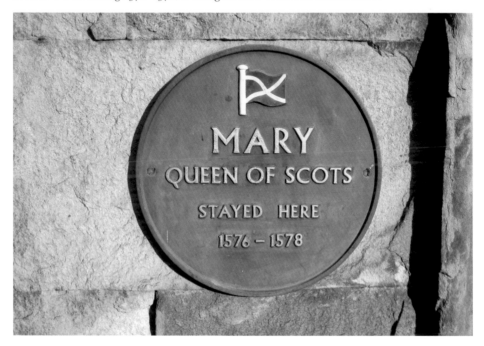

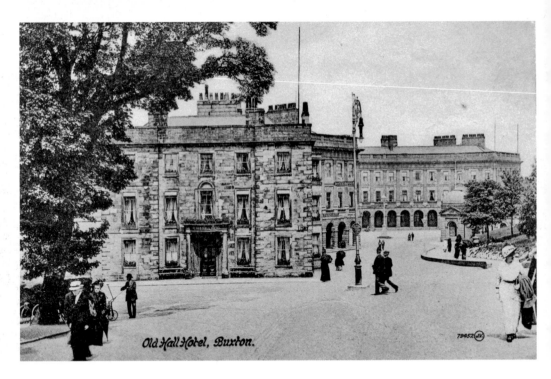

Old Hall Hotel, Buxton.

The Old Hall Hotel

The present day building of the Old Hall Hotel incorporates the original Buxton Hall building, which was greatly extended in 1670 to meet the increasing demand for treatments at the mineral water springs. The walls and other features of the earlier hall building were identified within the present structure during a 1990s investigation.

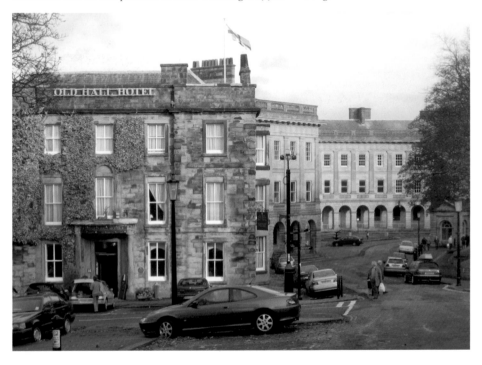

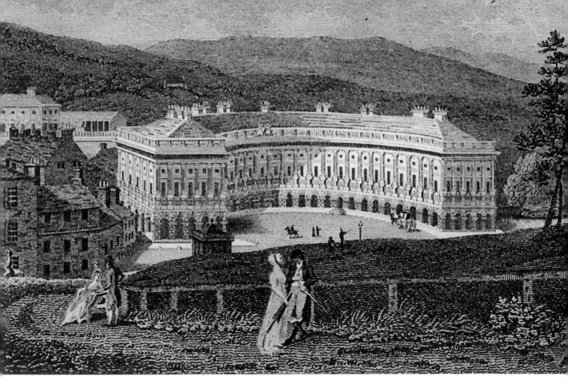

The Crescent

The next major development in that area was the construction of the Crescent for the Duke of Devonshire in the 1780s, close to Buxton Hall. The architect of the Crescent was John Carr of York. The upper picture shows the Crescent with its stable block behind (to the left). In the lower picture, St John's church, the Palace Hotel and the railway stations (1863) can also be seen together with various large residences.

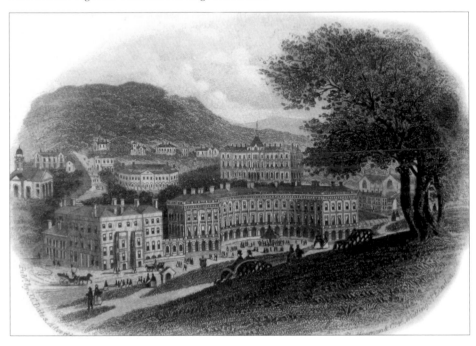

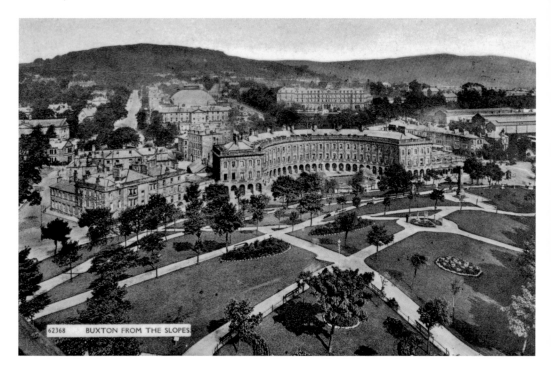

62368 BUXTON FROM THE SLOPES

The Crescent

In a later photograph, the dome has now been added to the former stable block. The Crescent is a Grade 1 listed building currently at the start of a major development project, many years in the planning. In its original form, the Crescent consisted of two hotels, a town house and shops at the colonnade level. The grassed area in front of the Crescent is known as the Slopes and the Pump Room can be seen at the foot of it.

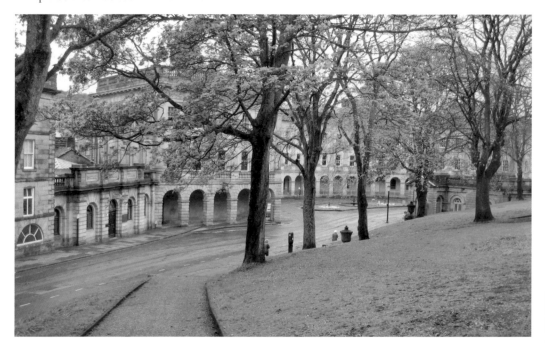

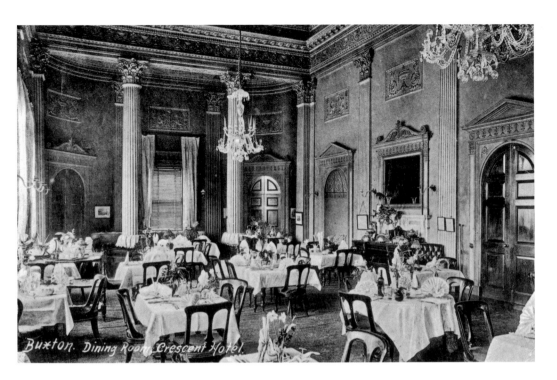

The Assembly Room

An outstanding feature of the Crescent is the room shown in the upper photograph, usually known as the Assembly Room but here laid out as the dining room of the Crescent Hotel. The lower photograph shows the east wing of the Crescent, which houses the Assembly Room. After the hotel closed, this end of the building was used as a hospital annex until 1963. Later, Buxton's public library was housed in this room for several years, which made each visit an impressive one.

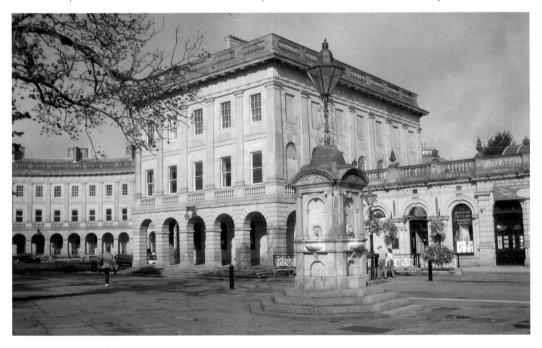

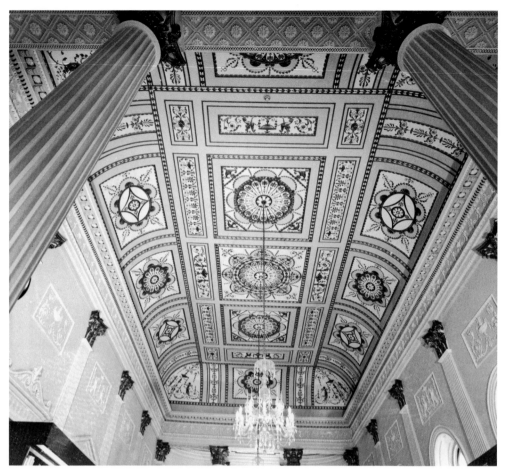

The Assembly Room Ceiling

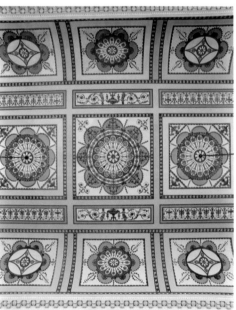

The Assembly Room is located at the top of an impressive staircase and has a card room attached. With a full programme of balls and other social events, it was the hub of the spa's social season, for which the magnificent Adam-style ceiling and its chandeliers would have created a striking scene. Buxton awaits the completion of the redevelopment project (currently scheduled for 2014), when the room will once more be on show.

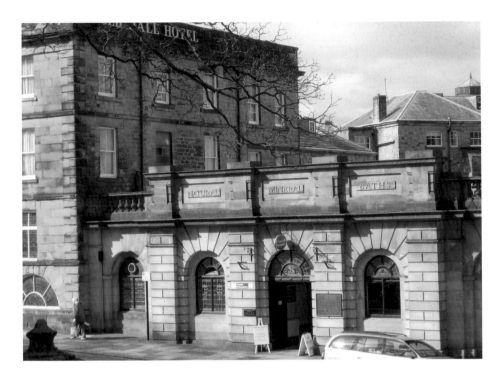

The Natural Baths

The source of the mineral water springs lies beneath the Old Hall and there has been a succession of baths on the site since Roman times. The present Natural Baths were rebuilt in 1851/52, with two ladies' private baths, two gentlemen's private baths, a public bath and a charity bath. The baths were fed by the spring water and, as well as bathing in the waters, visitors could also receive treatments for various conditions. The baths were again altered in 1923/24 when the present entrance on to the Crescent replaced one at the rear of the building.

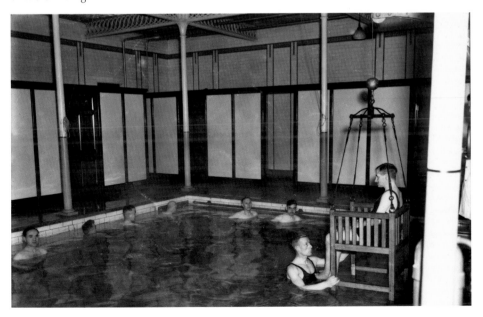

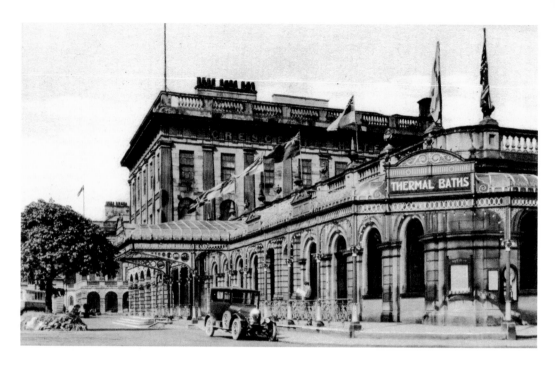

The Thermal Baths

These baths were built in 1853, adjacent to the east wing of the Crescent and rebuilt in 1900. They provided a range of hydrotherapy and massage treatments in individual small rooms until their closure in 1963. After a period of intermittent use, the building was converted into the Cavendish Arcade, which houses a range of small specialist shops.

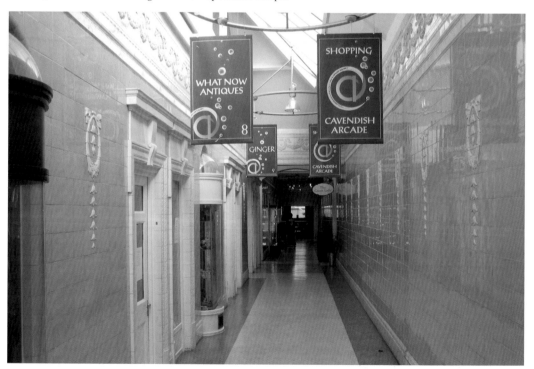

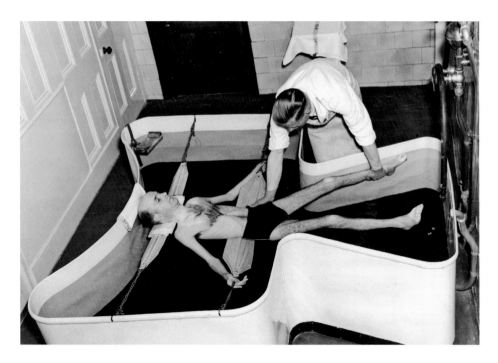

The Thermal Baths

The upper photograph shows one of the specialist hydrotherapy treatments carried out at the Thermal Baths where the patient is supported by slings in a floating position. In the lower photograph, the modern glass roof of the Thermal Baths gives the effects of light illuminating fallen autumn leaves.

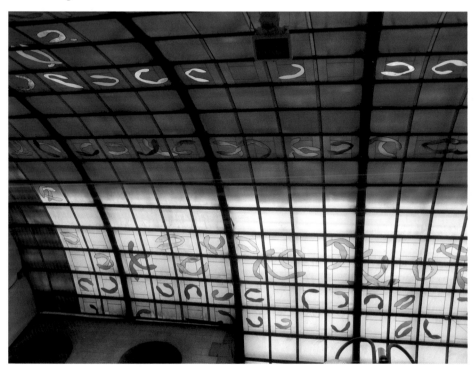

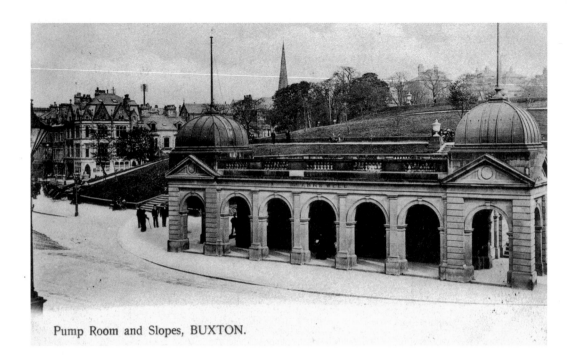

Pump Room and Slopes, BUXTON.

Pump Room and Slopes
The Slopes is a landscaped area linking the Crescent with Higher Buxton, laid out with paths decorated by large stone urns. The Pump Room is at the foot of the Slopes, facing the Crescent. In the upper photograph, the arches at the front of the Pump Room are open, as with the Crescent, but subsequently they were filled in with windows, as shown in the lower photograph.

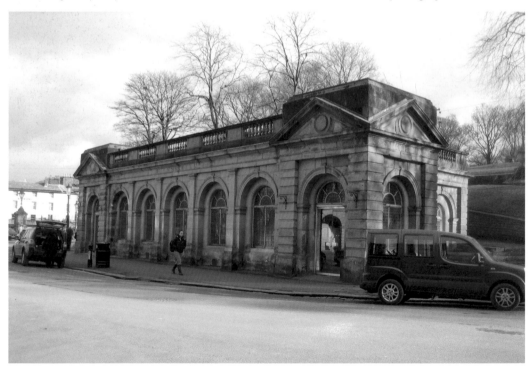

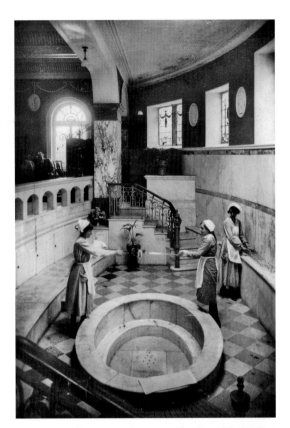

Taking the Waters

Mineral water from the springs was piped into the Pump Room and here visitors would pay to take the water served by an attendant from the marble basin in the floor. Tables and chairs provided a social area for visitors. The Pump Room was built in 1894. In recent years it housed the Tourist Information Centre. It is currently part of the Crescent restoration scheme.

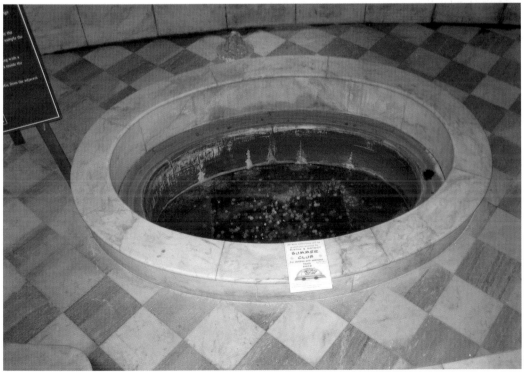

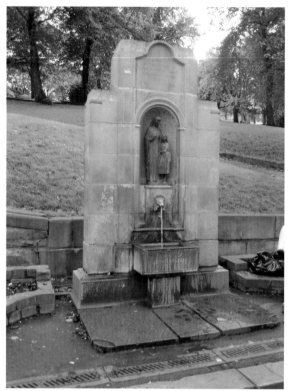

St Anne's Well

An Act of Parliament from the time of Elizabeth I requires that there should be a free supply of the water from the springs to inhabitants of Buxton. This free supply comes from St Anne's Well, located opposite the Natural Baths. The photographs on this page show the well at different eras. Nowadays, the spring water is also bottled at a modern bottling plant and Buxton Mineral Water has become a very popular brand.

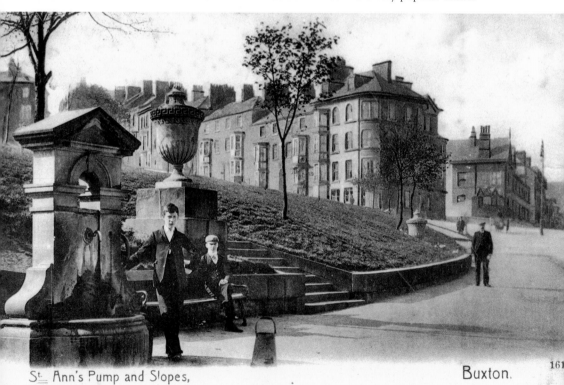

St. Ann's Pump and Slopes,　　　　　　　　　　Buxton.

161

Well Dressing

The tradition of dressing wells with floral decorations goes back a long way in Derbyshire and some neighbouring areas. It represents a celebration of the source of clean drinking water from the times when such supplies were hard to find. In Buxton the tradition was revived in the mid-nineteenth century and three wells are dressed each year, St Anne's Well, the Children's Well and the Market Place Well. The lower photograph shows the Queen, when she was still Princess Elizabeth, with Prince Philip at the 1949 dressing of St Anne's Well.

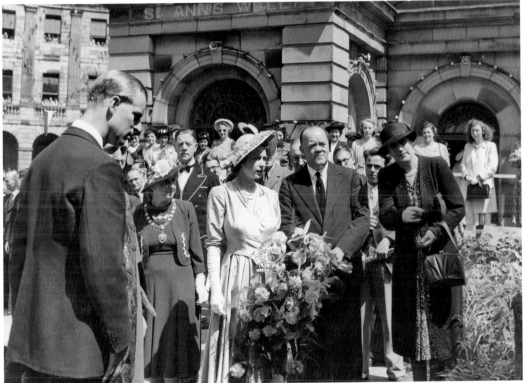

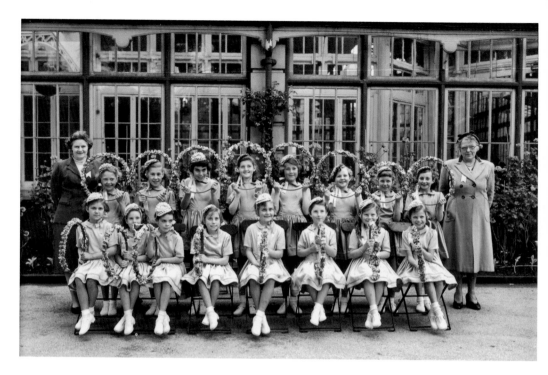

Well Dressing Processions

Well Dressing Week usually features a procession through the streets of Buxton. One feature of the procession used to be the Majorettes, troupes of marching girls (upper photograph). In 1976, Bill Weston invented Bill and The Billerettes as a humorous contrast to the female Majorettes and since that time the all-male Billerettes have made nearly a thousand appearances at local events, raising large sums for charity.

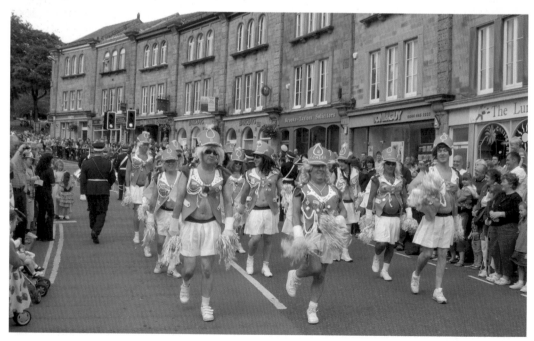

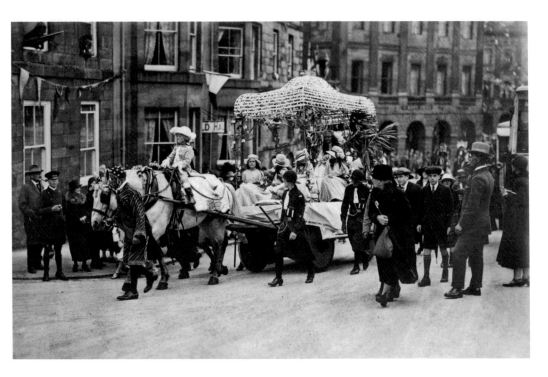

Well Dressing Processions

Other features of the processions are floats prepared by local societies, firms or social groups, with prizes for the best decorated float. Local brass bands and local employers also participate.

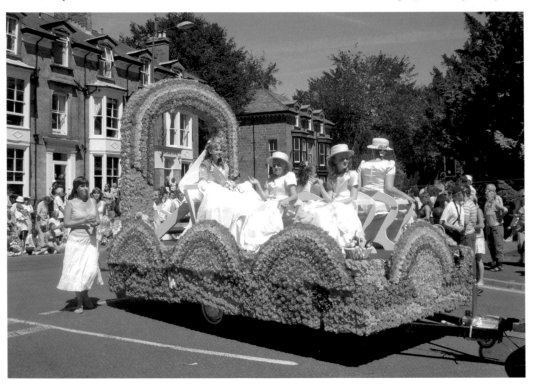

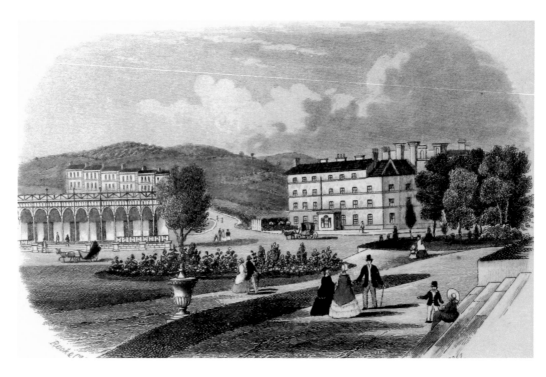

The Quadrant

The Quadrant leads uphill in a curving line from the side of the Thermal Baths. The upper picture shows the Thermal Baths, the Grove Hotel and the Quadrant, before the railway stations were built. The lower photograph shows additional buildings between the Grove Hotel and the Quadrant, and the surviving station in the gap between them.

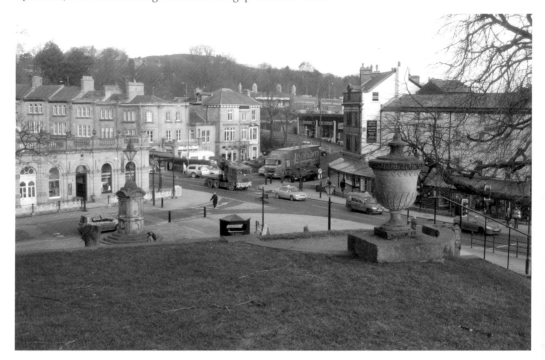

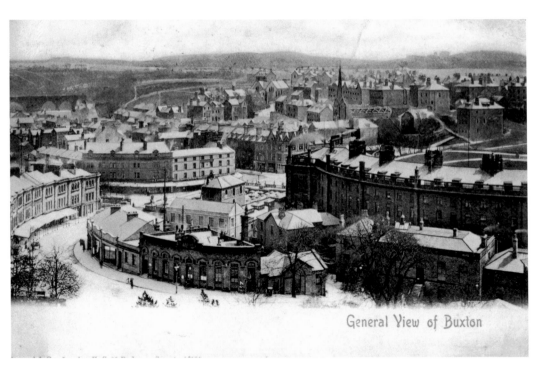

General View of Buxton

The Quadrant

The Quadrant curves round behind the back of the Crescent, with an elegant row of three-storey stone buildings to the left and an interesting variety of Victorian buildings, including the former post office to the right. In the lower photograph Station Road, a relief road constructed following the closure of one of the local railway stations in 1968, enters from the left at the roundabout.

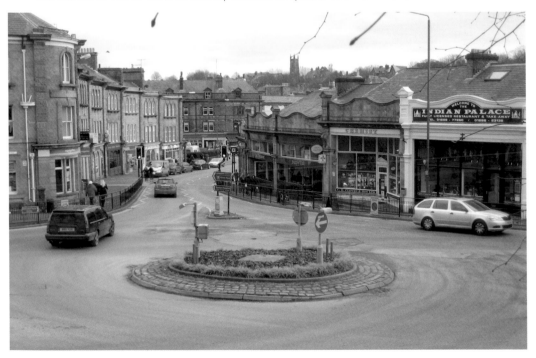

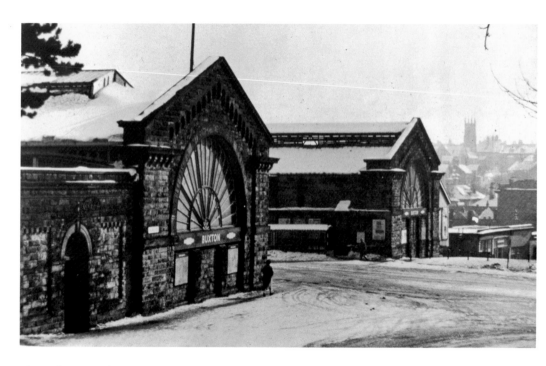

The Railway Stations

The railway era arrived in Buxton, after many years of arguments about routes through the Peak District, when twin stations were opened in 1863. In the upper photograph, the nearer building was the station for the line from Buxton to Manchester and the further building was the station for the line from Buxton to London St Pancras, via Millers Dale and Matlock. These stations were located a short distance uphill from the Quadrant.

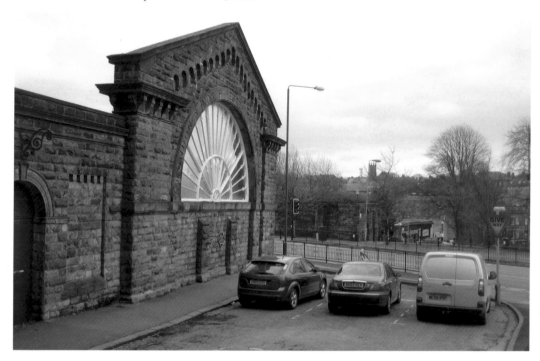

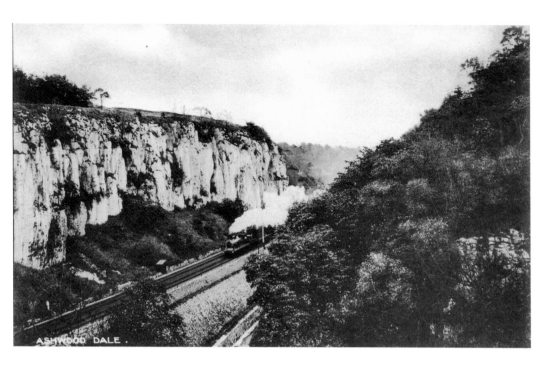

ASHWOOD DALE.

The Railway Stations

The upper photograph shows a steam train on the line from Millers Dale, travelling towards Buxton along Ashwood Dale where the River Wye, the A6 road and the railway are confined within the narrow dale. This line closed for passenger traffic in 1968 but it is still in use as a freight line. The station building shown in the lower photograph (and in the upper photograph of page 22) was demolished following this closure.

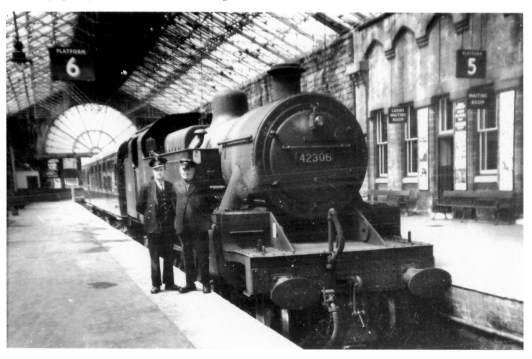

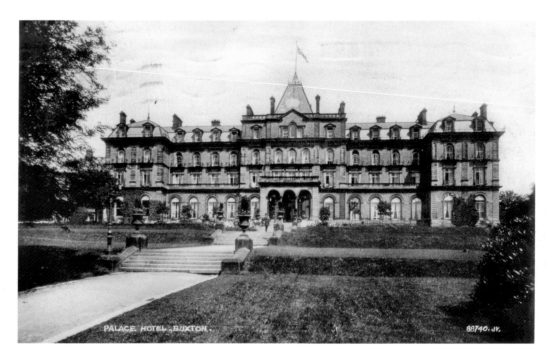

Palace Hotel

The Palace Hotel is located just across the road from the railway stations. When built in 1867 it was called the Buxton Hotel, but was renamed the Palace Hotel in 1868. This was shortly after the opening of the railway links that had resulted in a major increase in visitor numbers to the town. The hotel continues to thrive today with its health club and spa facilities and a steady flow of special events.

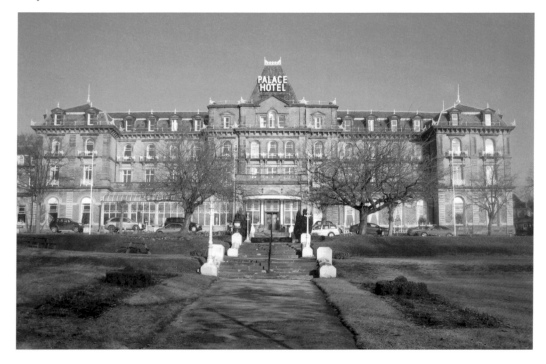

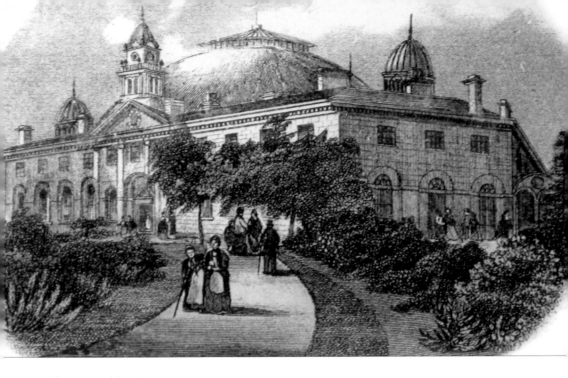

The Devonshire Dome

This building has a long and varied history. It started life as the stables building for the Crescent in a stone-built, octagonal form, with stables, spaces for coaches and accommodation for the associated staff. The huge central dome was added in 1881, to cover over the stable yard, and the clock tower above the entrance was added in 1882. It is now a campus of the University of Derby.

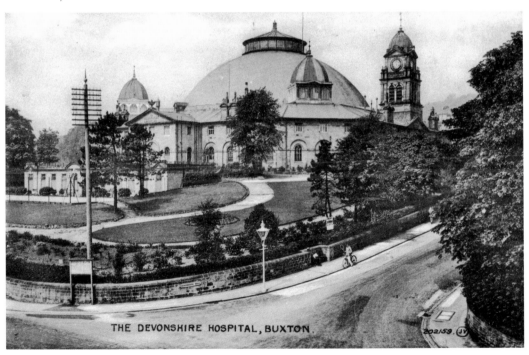

THE DEVONSHIRE HOSPITAL, BUXTON.

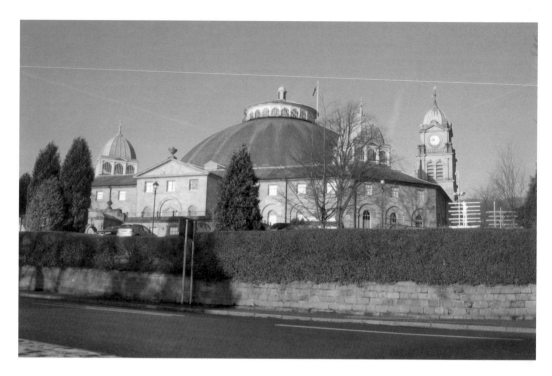

The Devonshire Royal Hospital

In 1859, part of the stables was converted to provide convalescent treatment for cotton workers, following which the whole building was progressively converted into a hospital, specialising in orthopaedic and rheumatic problems. It was designated as the Devonshire Royal Hospital in 1934 for its contributions in these areas. The dome was constructed to provide a covered area where patients could take exercise. The lower photograph shows the lantern at the top of the dome.

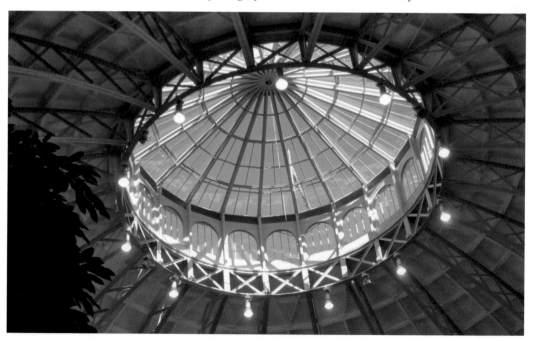

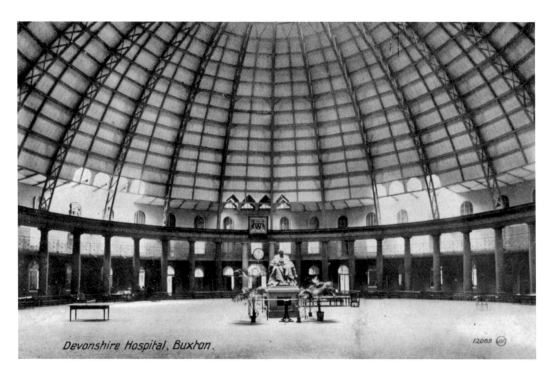

Devonshire Hospital, Buxton.

12089

The University of Derby

The upper photograph shows the huge interior of the dome, at one time the largest unsupported dome in Europe, with a statue of the Duke of Devonshire. The hospital closed in 2002 and, after extensive renovation, the building was officially reopened as a campus of the University of Derby by the Prince of Wales in 2006. The lower photograph shows a graduation ceremony in the dome.

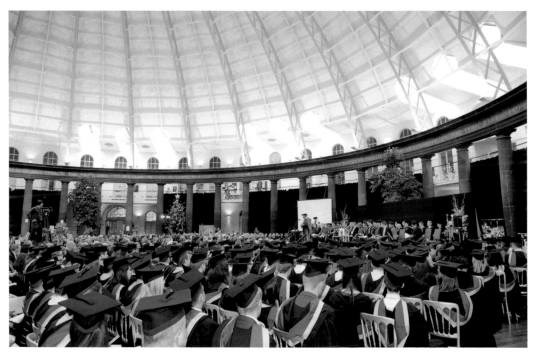

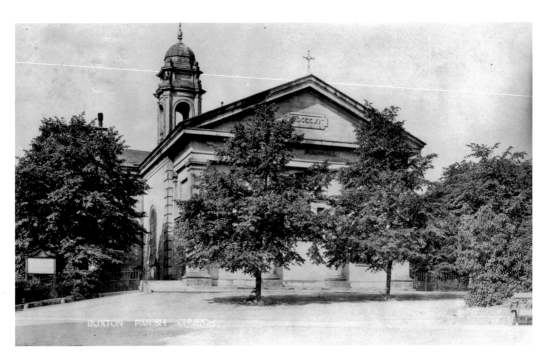

St John's Church

St John's church was built in 1811 to serve the religious needs of the growing number of visitors and residents in the general area of the Crescent. At that time, Buxton's church was St Anne's at the further end of Higher Buxton, some distance from the developing fashionable spa.

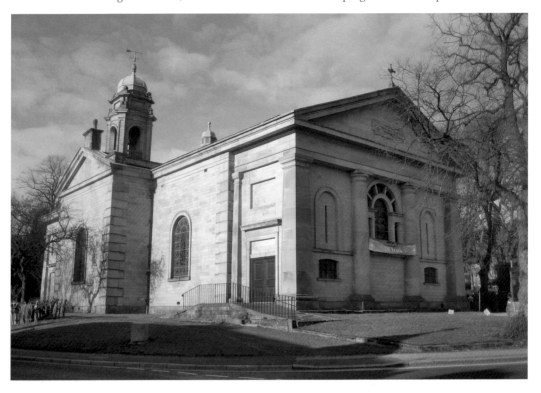

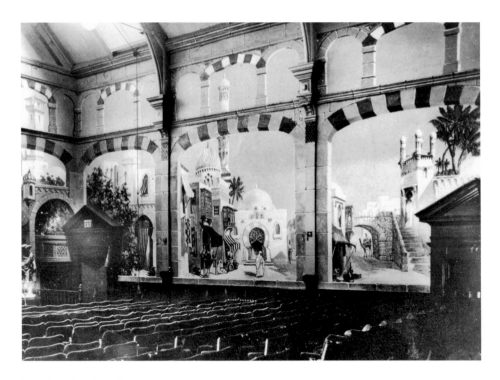

The Pavilion Arts Centre

The oldest surviving theatre building in Buxton was built opposite St John's church in 1889. Known at various times as the New Theatre, the Hippodrome and the Playhouse, the building has now been converted to a multi-purpose arts centre for studio productions, smaller-scale dramas, concerts and lectures. It is also home to three youth theatre groups.

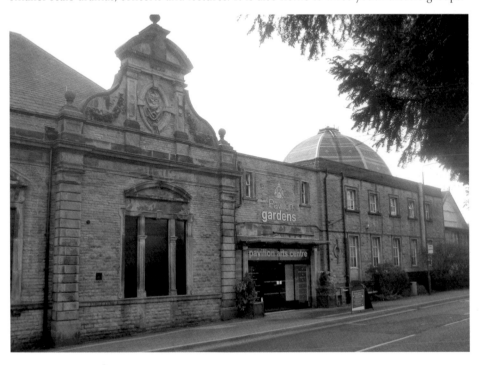

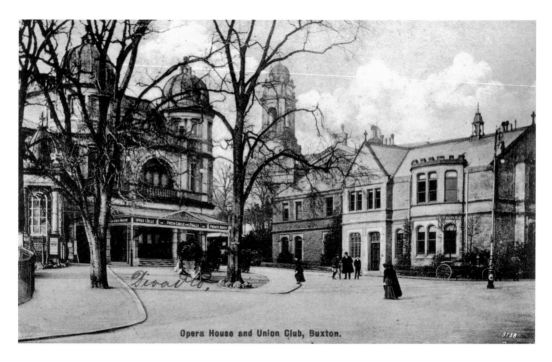

Opera House and Union Club, Buxton.

The Opera House

The Opera House, designed by the famous theatre architect Frank Matcham, was built in 1903 next to the main entrance to the Pavilion Gardens. After a period as a theatre in the inter-war years it was converted to a cinema in 1927, but this closed in 1976. It was reopened as a theatre in 1979 after a partial restoration project and the first of the highly successful Buxton Opera Festivals took place later that year.

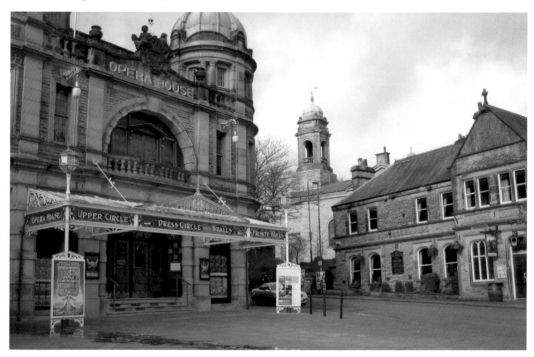

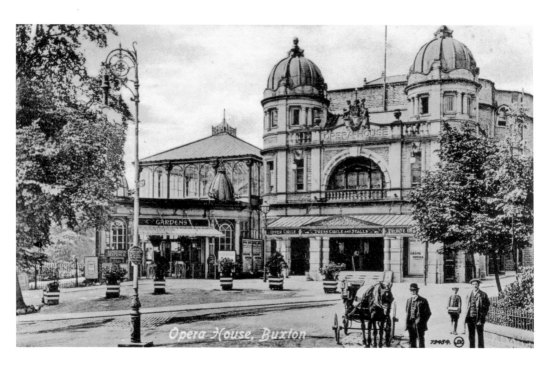

The Opera House

The interior of the Opera House is richly decorated in an Edwardian style. In addition to the annual Opera Festival with its associated Literary Festival and Festival Fringe, which go from strength to strength, it hosts the International Gilbert and Sullivan Festival, a jazz festival and numerous touring drama and musical productions, totalling over 400 performances a year.

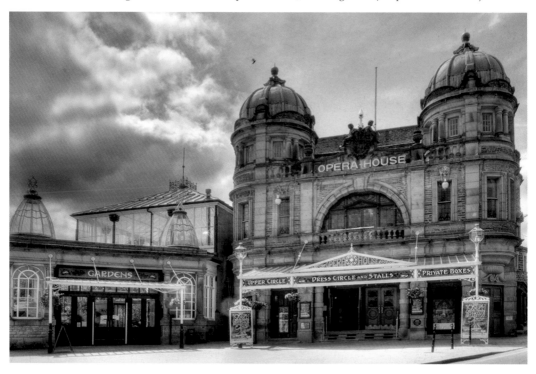

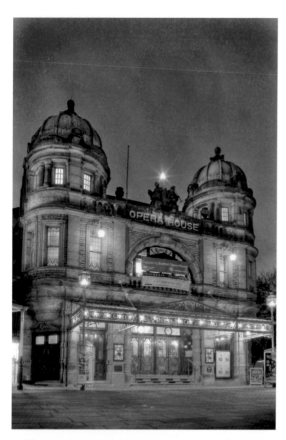

The Opera House
The upper photograph shows the theatre at night, while the lower photograph shows the auditorium during a concert held following the restoration of the internal decorations and the external structure in 1999–2001.

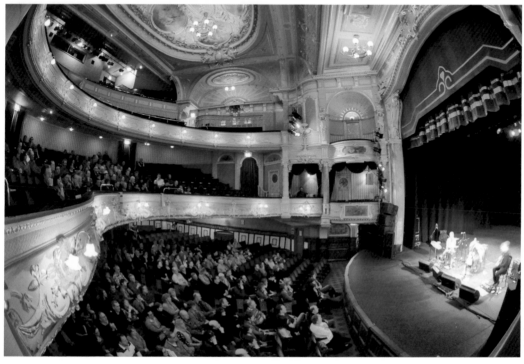

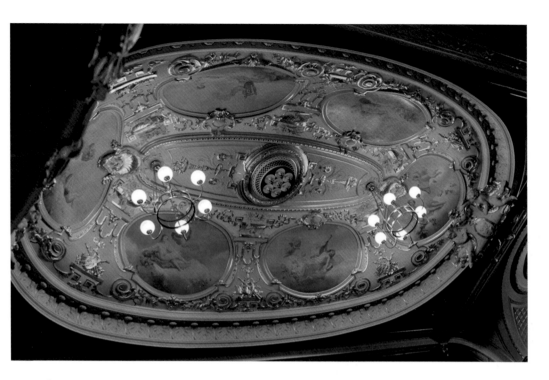

The Opera House

The central decoration in the ceiling of the auditorium was carefully restored and other decorations were re-gilded under the watchful gaze of the cherubs. The theatre's interior ranks as one of the finest examples of Matcham's work in the country.

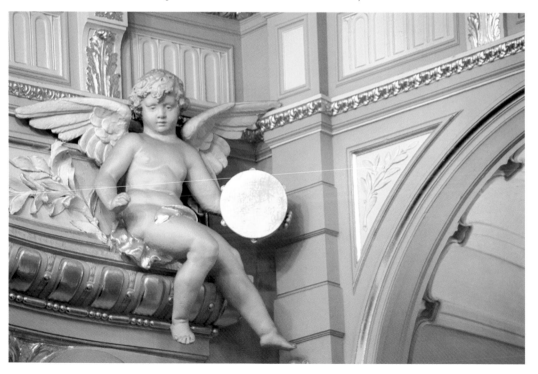

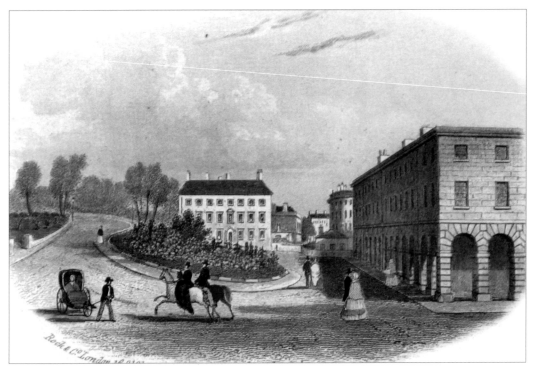

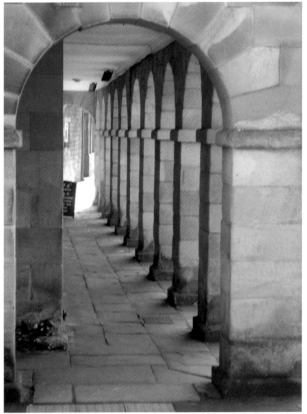

The Square

Opposite the Opera House is a block of apartments commissioned by the Duke of Devonshire and built in 1803–1806 to provide extra accommodation for visitors to the developing spa. This block, known as the Square, has stone arched colonnades along two sides. Because of the lack of space in the narrow Wye valley, the Square is built across the river. The George Inn (to the left of the Square) was built on the original line of the Manchester turnpike in the 1770s.

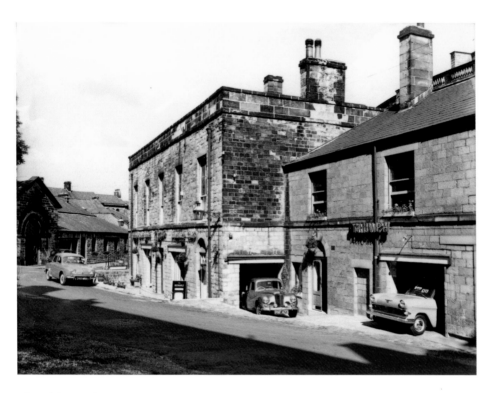

The Old Courthouse

This set of buildings is located at the back of the Crescent. Dating from the mid-nineteenth century, they have at various times served as council offices, meeting rooms and, as shown in the upper photograph, Oram's car showrooms. More recently, the buildings have housed a variety of small shops catering for visitors. They currently serve as four restaurants and bars ranging from French bistro to Tex-Mex.

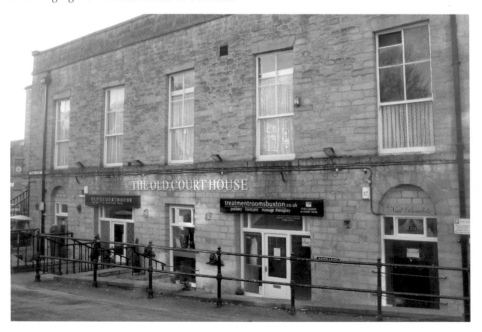

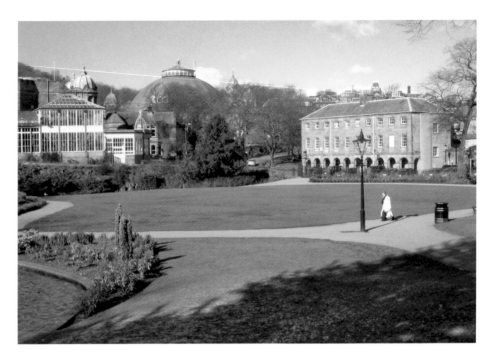

Return to the Old Hall Hotel

These photographs complete the circuit of the core of Buxton's historic centre. The upper photograph shows the Square from the Pavilion Gardens, while the lower photograph shows the front of the Old Hall Hotel seen from across the lower lake of the Pavilion Gardens. The gardens of Buxton Hall were originally laid out as a parterre. The lake is one of three later created on that branch of the Wye. The weir for the smallest of the three at Wye Head, where the Wye emerges from an underground passage, has long since collapsed.

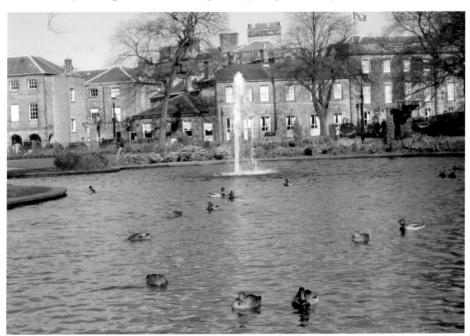

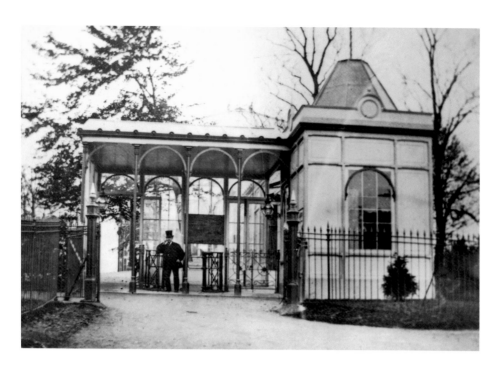

Pavilion Gardens

The Pavilion Gardens, a 23-acre landscaped open space and a complex of buildings in iron and glass, were first opened in 1871 on a 12-acre site and the gardens were extended to their present size in 1876. Originally, there was an admission charge to the gardens and an entry point, close to where the Opera House now stands, is shown in the upper photograph. The original building had a large central hall and a symmetrical pair of extensions, giving the long frontage shown in the lower photograph. Two branches of the Wye flow though the gardens and meet near the site of this entrance.

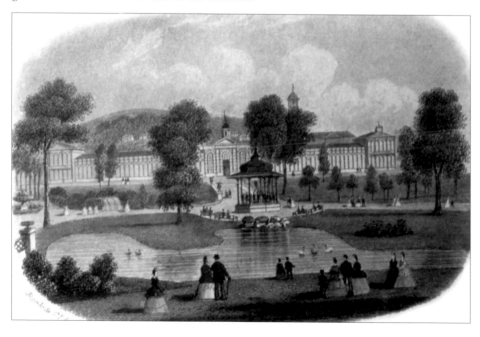

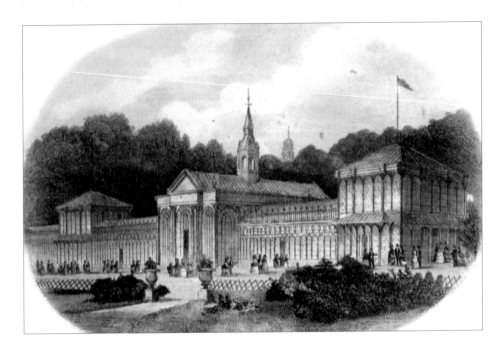

Pavilion Gardens Buildings

There have been several changes to the buildings over the years as the Octagon, Playhouse and Opera House have been added. The large central hall remains relatively unchanged externally. It was rebuilt in 1983 after a serious fire and it is now a two-level restaurant and coffee lounge. The wing to the left houses the Tourist Information Centre, a shop featuring local produce and the Gallery In The Gardens, a show place for local works of art, including paintings, pottery, embroidery.

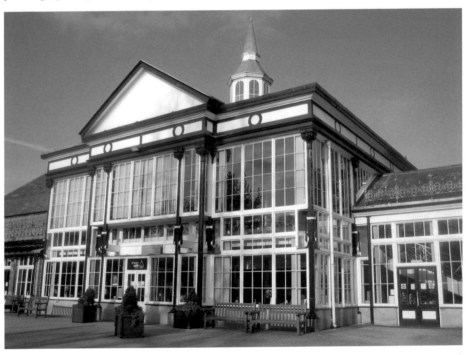

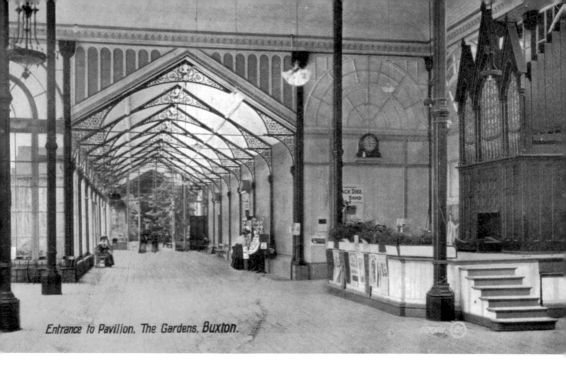

Entrance to Pavilion, The Gardens, Buxton.

Conservatory

The upper photograph shows one of the original wings of the building, illustrating the method of construction. Amongst other things, it was used as a small concert hall, with its organ and stage. This wing was replaced in a similar form of construction when the Opera House was built. It was arranged in 1982 into its present layout as a Conservatory (lower photograph), with a wall displaying spectacular aerial photographs of the Peak District.

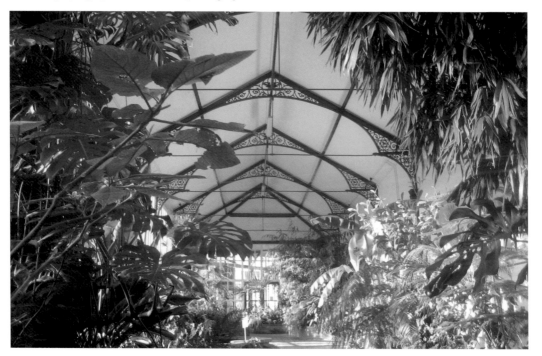

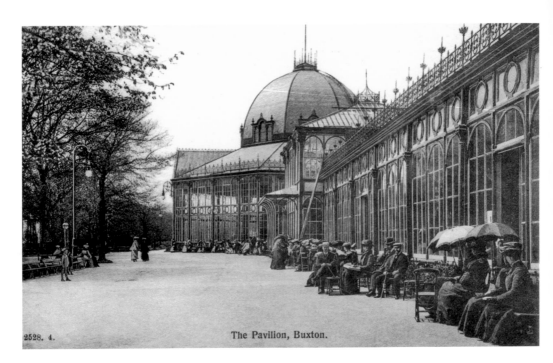

The Pavilion, Buxton.

2528. 4.

The Octagon

The most prominent of the iron and glass buildings in the Pavilion Gardens complex is the Octagon, constructed in 1876. It provides a large indoor space for antiques fairs, farmers' markets, tea dances, concerts and a variety of other events. As a concert hall it has room for an audience of 800.

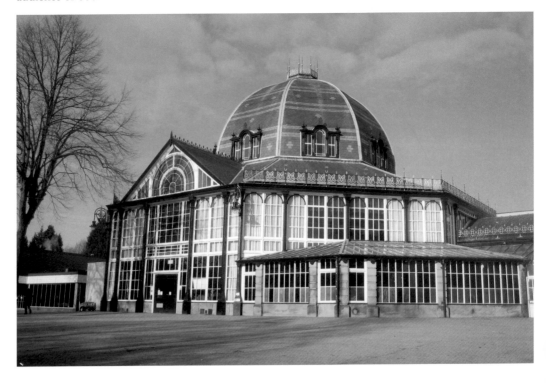

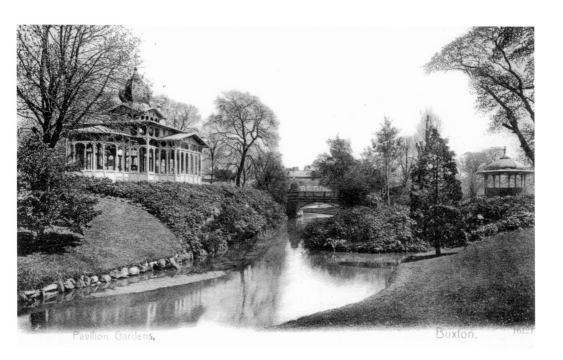

Tea Houses and Bandstands

As well as the main buildings there have been other small buildings and bridges in a similar style in the gardens. The upper photograph shows the Oriental Tea Kiosk, built in 1899, which was a popular location for relaxation. It was demolished in 1977 due to a risk of collapse. The lower photograph shows a modern bandstand built in 1998 in the traditional style, on the base of a previous structure, adjacent to one of the bridges. It is a regular venue for band concerts and weddings.

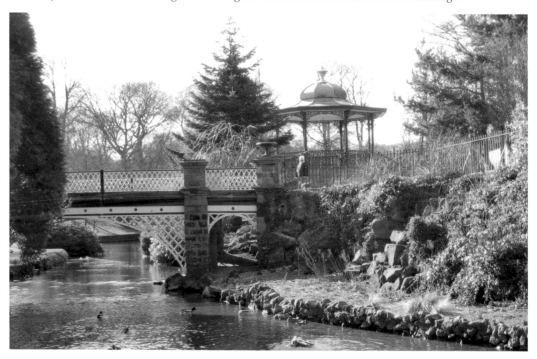

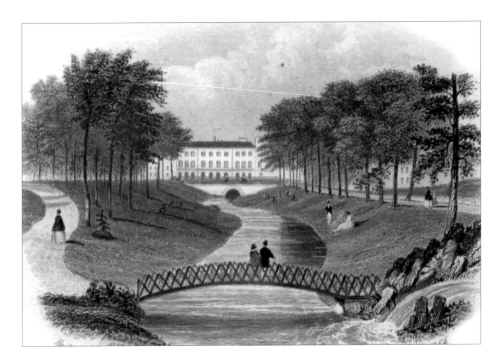

Ornamental Bridges

The Wye has been used to enhance the visual interest in this area for many years. Decorative waterfalls have been constructed and rustic bridges, later replaced in iron, have been widely used. In the upper photograph, looking towards the Square, the descent of the Wye into a culverted section can be seen. With the exception of one short stretch, the Wye does not reappear until Ashwood Park because of the pressure on space in the narrow valley.

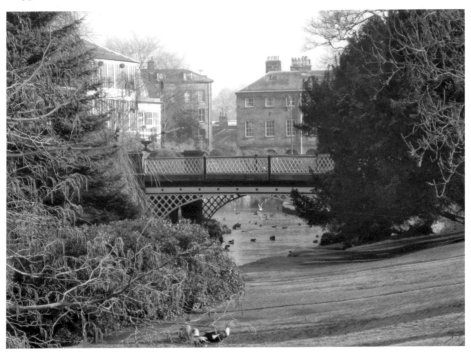

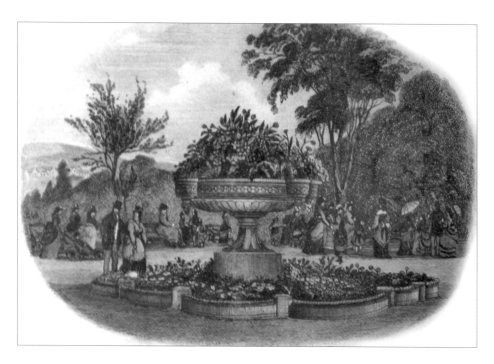

Urns

After a period of absence, this large, decorated urn was restored to its original position during a major restoration of the Pavilion Gardens that began in 1998 and involved, amongst other things, draining and relining the large lake.

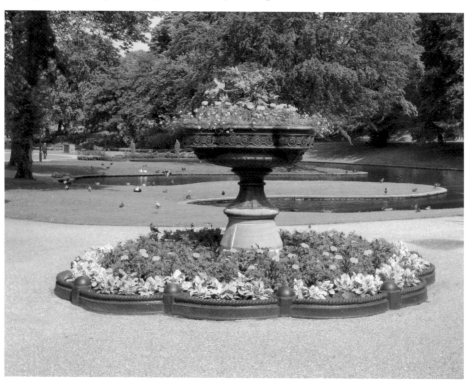

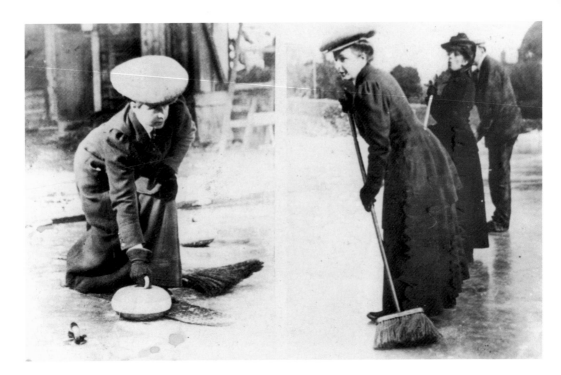

Sporting Activities

In the 1900s, there was a flourishing curling club based in the Pavilion Gardens. Curling took place on a specially constructed rink, with illumination so that play could continue after dark. Tennis tournaments were played in the Pavilion Gardens from 1884 until the 1950s (apart from wartime years), with a stand for spectators, including at one time the All-England Ladies' Doubles Championship. Croquet was also popular.

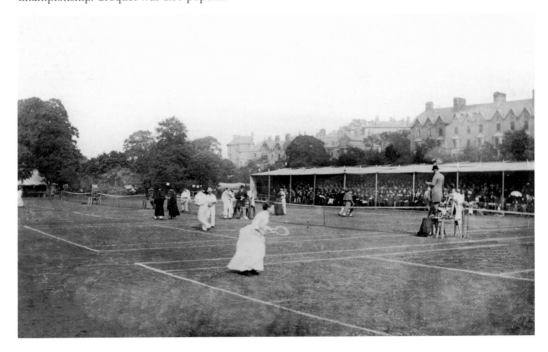

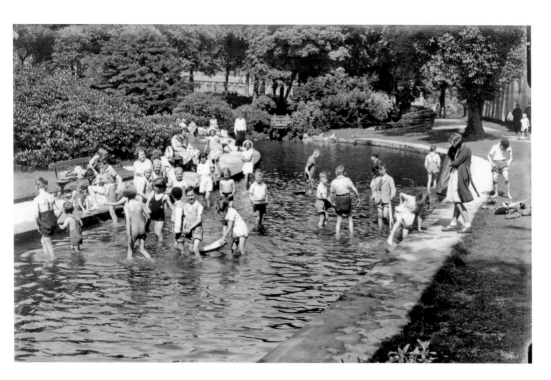

Facilities for the Children

As well as paddling in the river, children can also enjoy a ride on a train or spend time in the two play areas. The area for older children has recently been fitted out with new equipment.

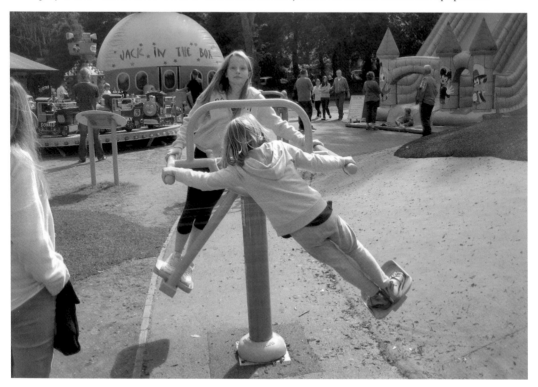

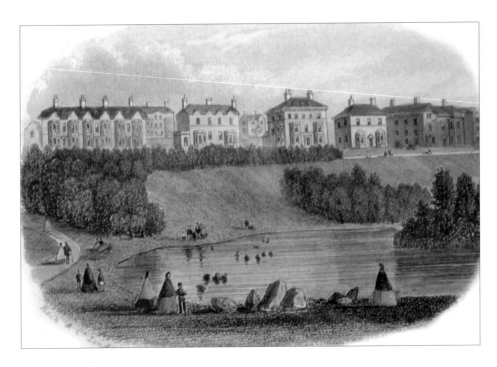

The Upper Lake

The upper lake, fed by the branch of the Wye that flows under Grin Low and through Poole's Cavern, lies close to Broad Walk at one edge of the Pavilion Gardens. Broad Walk is a pedestrian terrace originally bordered by detached villas and small hotels. It was a boating lake at one time but is not used for boating nowadays, although there is still a landing stage.

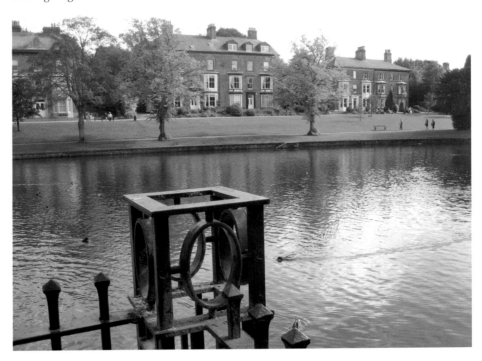

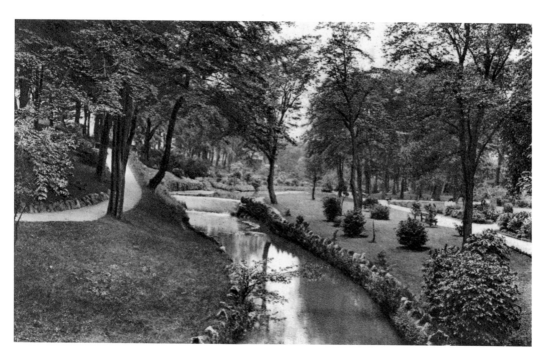

Serpentine Walks

Originally, the Serpentine Walks were tree-fringed paths and walks on both sides of the Wye stretching from the Old Hall to Gadley Lane. They were decorated with small waterfalls and rustic bridges and were a popular walking area for visitors. The Pavilion Gardens have now taken over part of that route, but beyond the gardens the Serpentine Walks still retain their rustic charm.

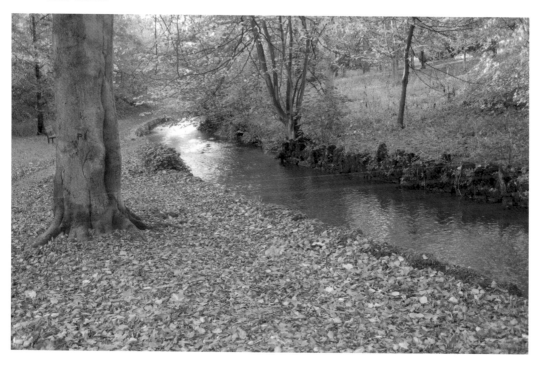

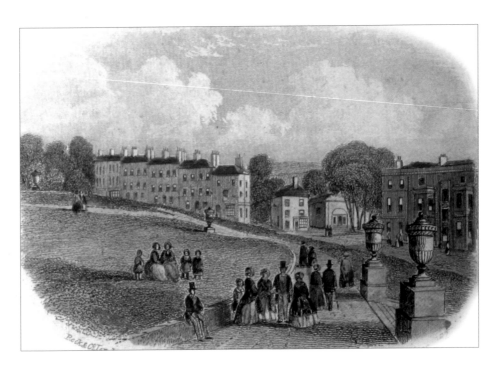

Hall Bank

Hall Bank is a terrace of houses built in the 1800s on one side of the Slopes. It links the area around the Old Hall with Higher Buxton and is close to the original route of the Roman road through the town and to the original Buxton to Manchester turnpike, before it was diverted to what is now Terrace Road following the building of the Crescent.

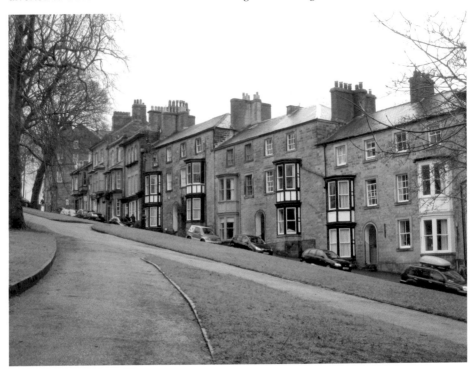

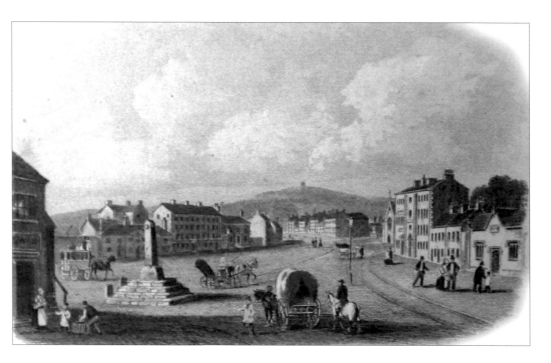

Market Place

At the top of Hall Bank the road enters Buxton market place, with the Kings Head public house and market cross to the left and Eagle Parade and the Eagle Hotel to the right. The market place has a long, narrow shape dating from the early days of the town, with a view to Grin Low on the southern side of Buxton. The lower photograph shows the market cross.

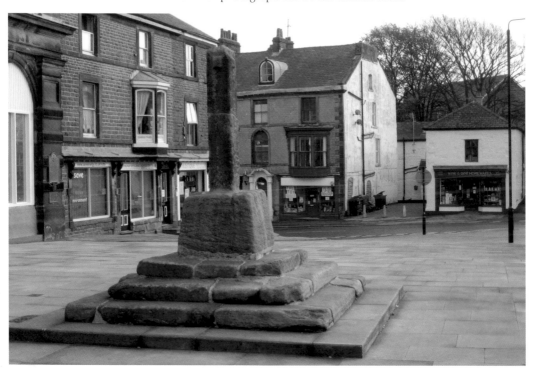

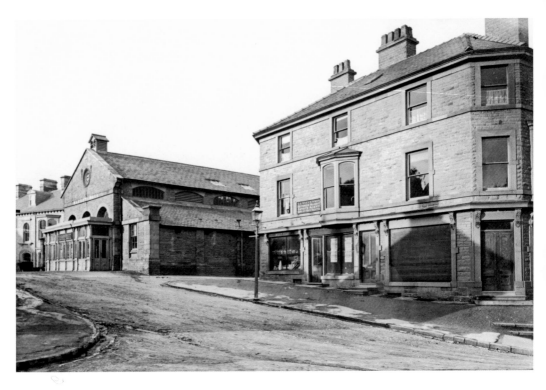

The Town Hall

The upper photograph shows, from right to left, a parade of shops, the market hall and the King's Head. The market hall was destroyed by fire in 1885 (see page 60) and the Town Hall was built on that site, replacing the local government offices formerly located in the old courthouse (page 33).

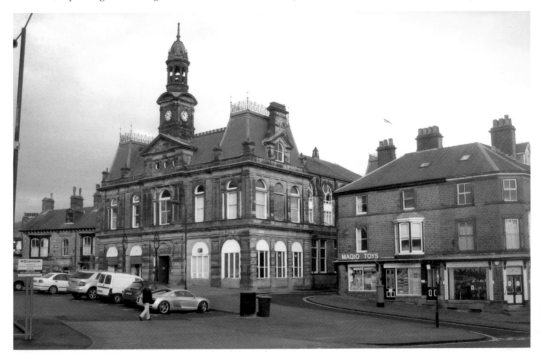

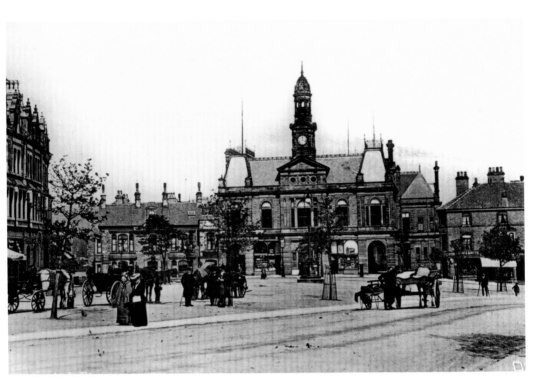

The Town Hall

The Town Hall was built fronting on to the market place with a tall central clock tower. The other side of the building looks on to the Slopes, with a fine avenue of mature tress leading up to it with a French château effect.

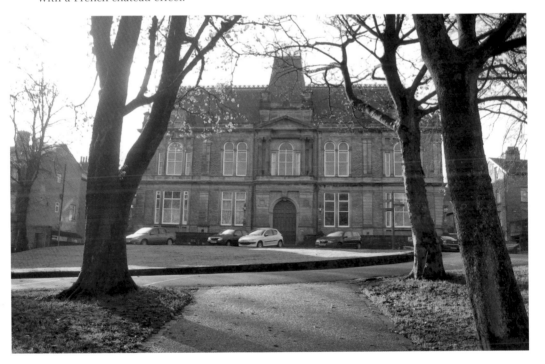

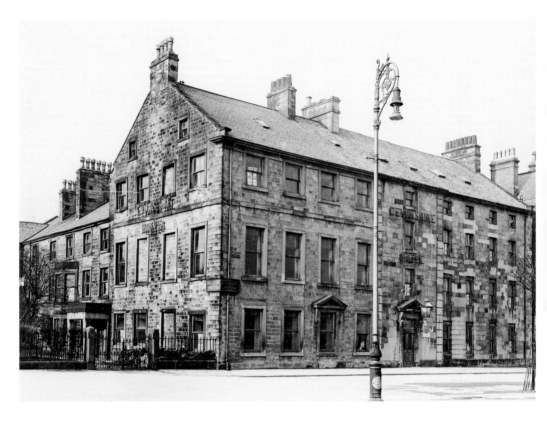

The Eagle Hotel

There was an inn known as the Eagle and Child recorded in 1592; the Eagle Hotel is thought to be on the same site. It was rebuilt in 1760. In recent years, part of the site was occupied by a furniture store, but that part is currently unoccupied.

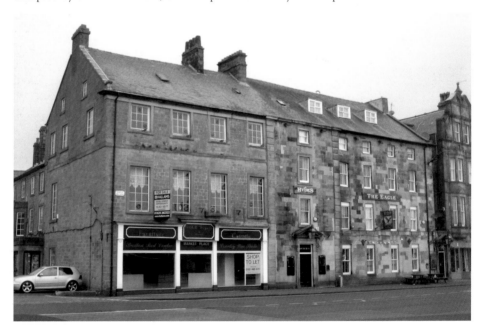

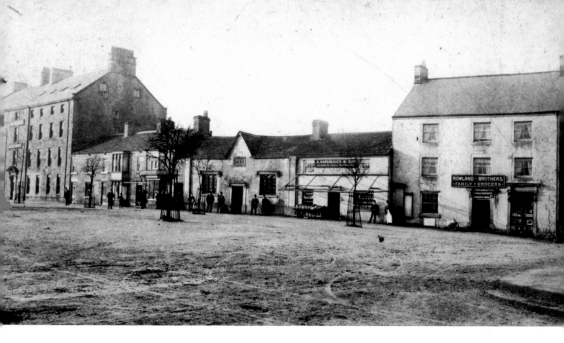

Eagle Parade

Adjacent to the Eagle Hotel there was an array of smaller buildings, including several shops and a school. These buildings were replaced by Eagle Parade, a three-storey building with shops at street level.

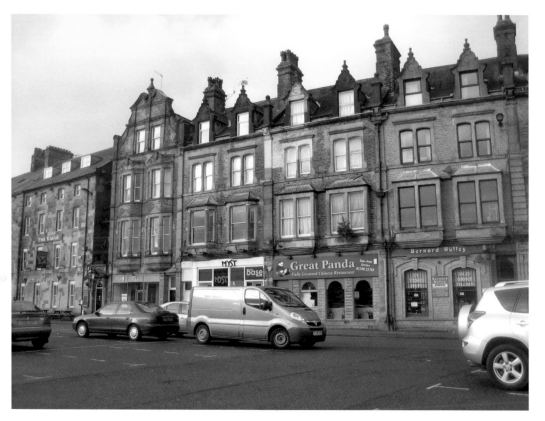

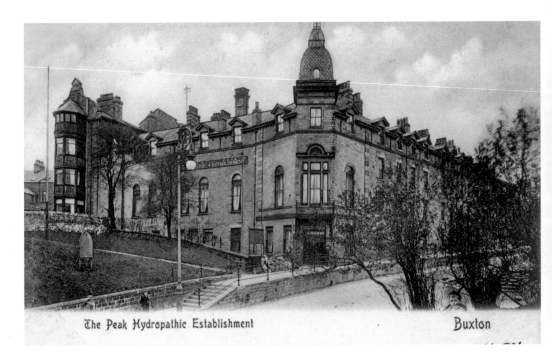

The Peak Hydropathic Establishment Buxton

The Peak Hydropathic Establishment

As Buxton developed as a spa resort, several large hotels and hydropathic establishments were built in the town. The Peak Hydropathic Establishment was built in 1870 at the top of Terrace Road, opposite the Town Hall. The building now houses the local magistrates' court and the Buxton Museum and Art Gallery, which has good local displays and several large rooms for exhibitions.

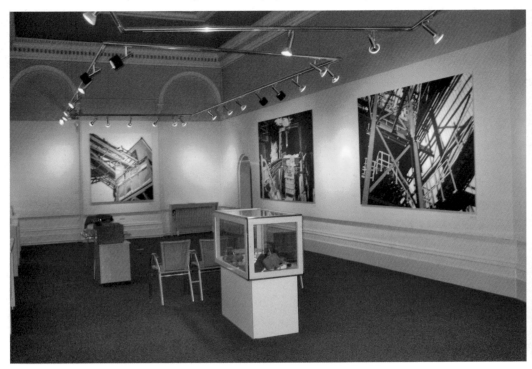

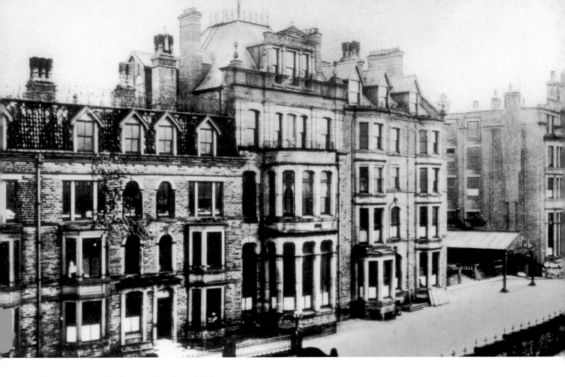

The Buxton Hydropathic Establishment
This was another large spa related development located between the market place and Broad Walk. The lower photograph shows its elaborate ballroom. During the First World War, it operated as the Granville Military Hospital. It was later renamed as the Spa Hotel. The building was demolished in 1973 and the site used for housing.

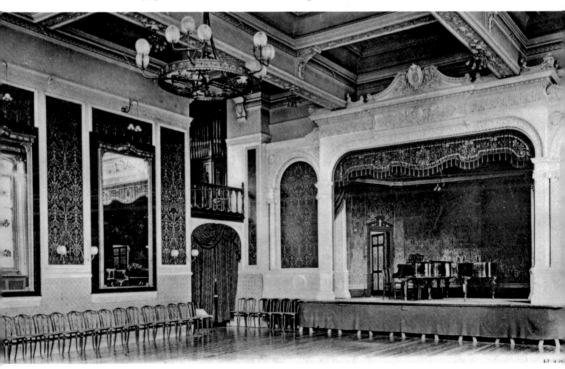

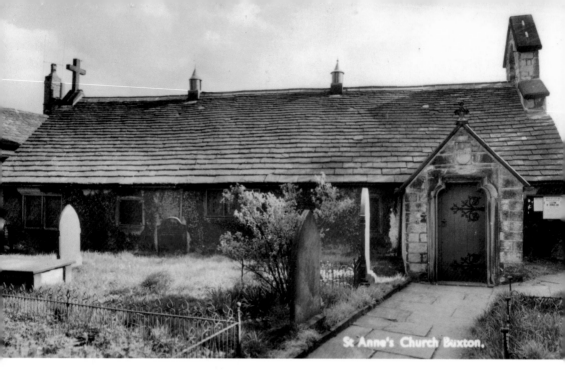

St Anne's Church

The earliest recorded date for a chapel in Buxton is 1489, but there may have been one at an earlier date. The present St Anne's church has a font with the carved date of 1625, although it is of Norman design. It was extensively restored in 1956/57.

Local Inns

The market place/St Anne's area was the original location of Buxton village and there is a cluster of five public houses within two minutes' walk of the church. These date from the era of horse-drawn traffic and several still have their stable yards, which catered for local trade rather than the spa visitors. As a sign of the times, the Baker's Arms, just below the church, closed recently and is being converted into houses.

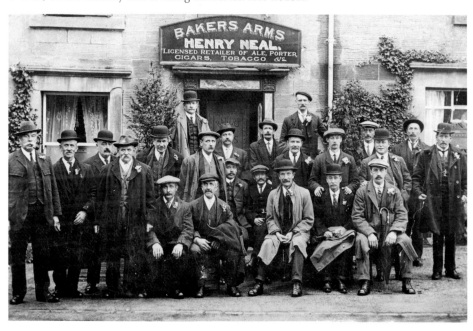

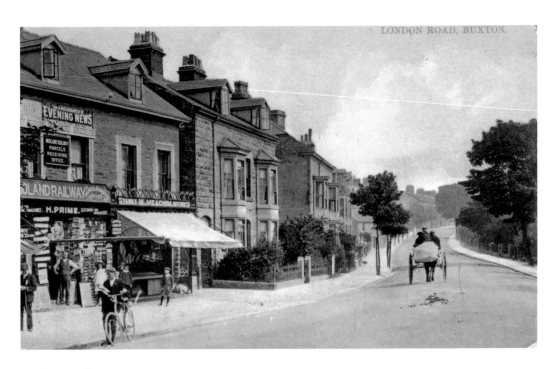

London Road

London Road leads south from the town centre towards Ashbourne. For the first few miles, it more or less follows the route of the main Roman road across the Peak District and it became the first turnpike in Derbyshire in 1724, linking Buxton with Manchester and subsequently with Derby via Ashbourne.

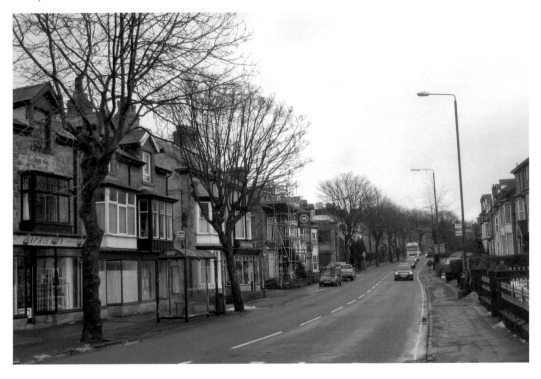

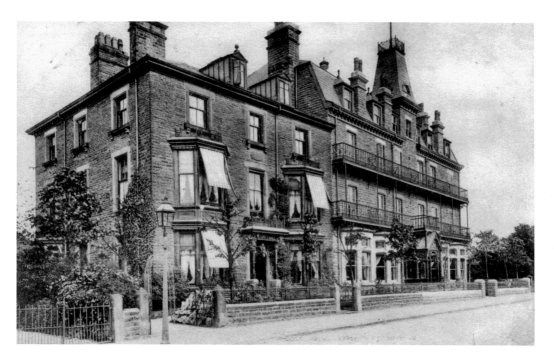

Haddon Hall Hydro

The Haddon Hall Hydro and Oliver's Hydro stood on a site a short distance down London Road. In recent years they were used as a training centre and conference centre, then as apartments. They were standing empty, awaiting the outcome of a planning application that would have retained the elegant frontage, when they were gutted by a fire. Some weeks later the shell of the building became unstable and it required total demolition.

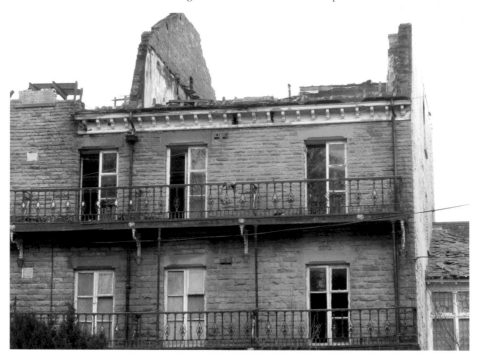

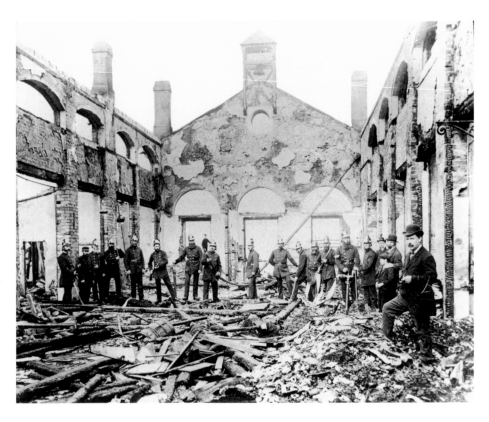

Fires and Firemen

A previous serious fire occurred in Buxton in 1885, when the market hall was destroyed, leaving the ruin shown in the upper photograph. The lower photograph shows the local fire brigade participating in the Peace Celebrations of 1919.

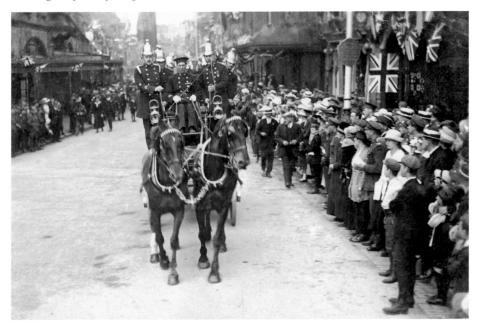

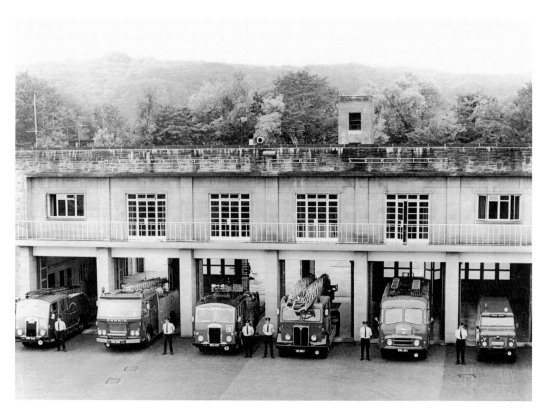

Fire Stations

The fire station has had many locations over the years. Until recently it was located in Compton Grove (upper photograph) within 200 metres of the Haddon Hall Hydro, but even this was not enough to save that building. A new Fire and Rescue Centre a short distance down the road opened in 2011. This Centre also provides accommodation and training facilities for local volunteer cave and mountain rescue teams.

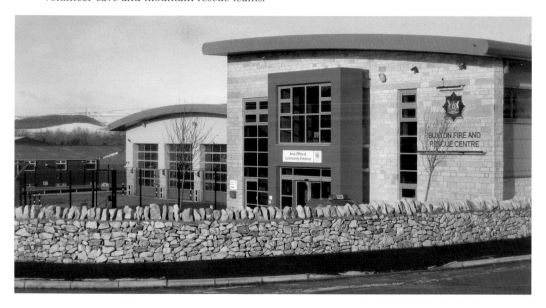

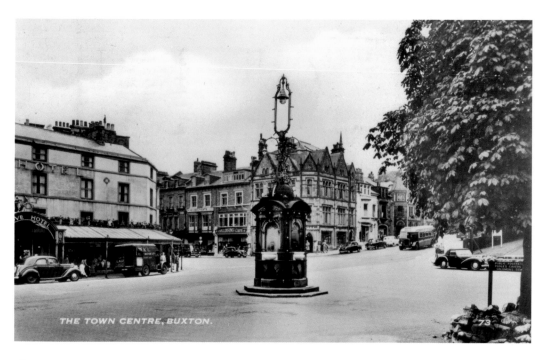

The Town Centre

Returning through Higher Buxton and descending on Terrace Road takes one to the centre of present-day Buxton, along the line of the main road through town. The large memorial, named after Samuel Turner who died in 1876, stands close to the junction of the Crescent, the Quadrant, Terrace Road and Spring Gardens, which is the main shopping centre in the town. The white building is the Grove Hotel, an eighteenth-century coaching inn.

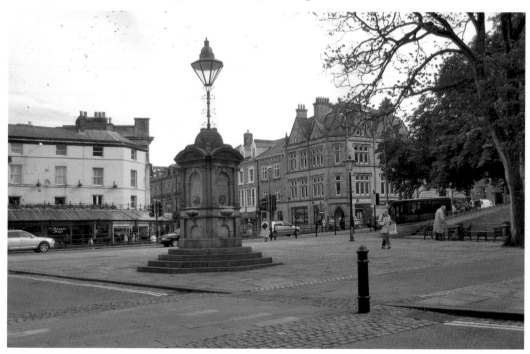

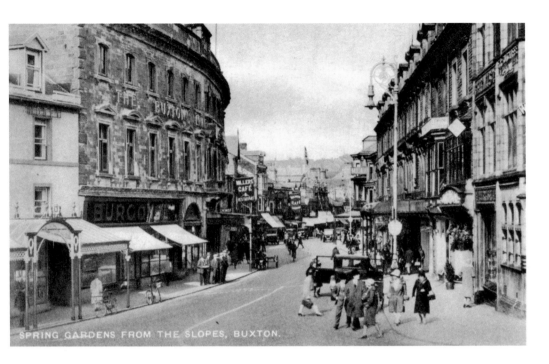

SPRING GARDENS FROM THE SLOPES, BUXTON.

Spring Gardens

Looking along Spring Gardens from Terrace Road, the most obvious change is the pedestrianisation of the road that was made possible by the construction of Station Road. Originally the turnpike road to Sheffield, Spring Gardens has a varied range of buildings from the early nineteenth century to the late twentieth century and a good mixture of both independent and national shops and cafés.

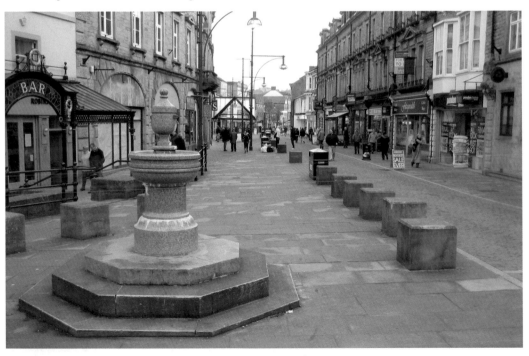

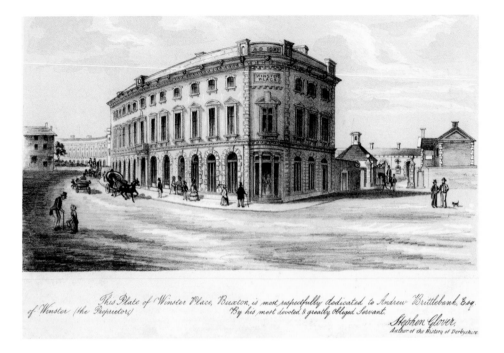

This Plate of Winster Place, Buxton, is most respectfully dedicated to Andrew Brittlebank, Esq. of Winster (the Proprietor) By his most devoted & greatly Obliged Servant. Stephen Glover, Author of the History of Derbyshire.

Royal Hotel

The Royal Hotel was built in 1849–51, on the site of the former Angel Inn, and the building has had various uses over the years. In the lower photograph, the glass and steel structure marks the entrance to the Spring Gardens Shopping Centre, constructed in the 1970s and housing a useful variety of shops tucked away behind Spring Gardens itself. Part of the shopping centre is built across the river.

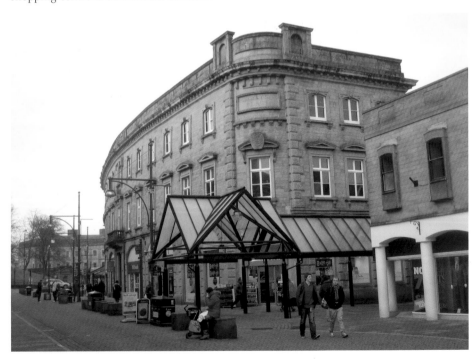

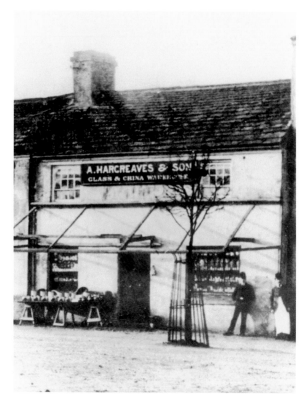

Hargreaves

One of the longest established businesses in Buxton, Hargreaves started out in its glass and china business in a shop on the market place in 1865, where Eagle Parade now stands, and moved to Spring Gardens in 1904. The Edwardian Tea Rooms opened in the 1988.

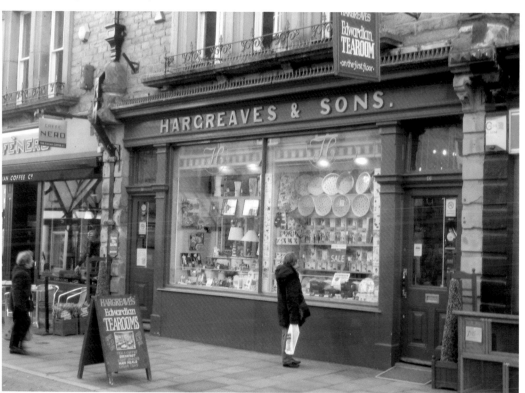

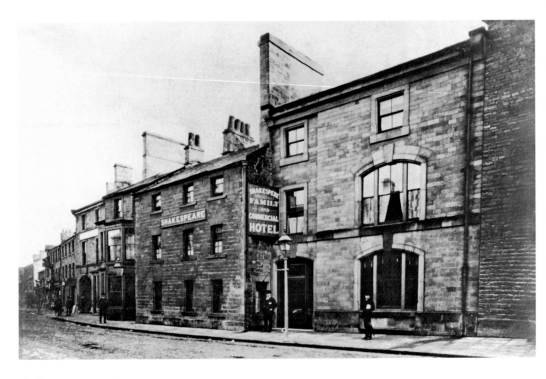

Shakespeare Hotel

The Shakespeare Hotel (upper photograph) was built in 1711 close to where the earliest theatre in Buxton is thought to have been located, hence the hotel's name. Part of the site was redeveloped by Woolworths in 1926 and following that firm's closure it was taken over by an outdoor pursuits shop. The arch that led to the hotel's stable yard is still in place, now leading to the Shakespeare Garage.

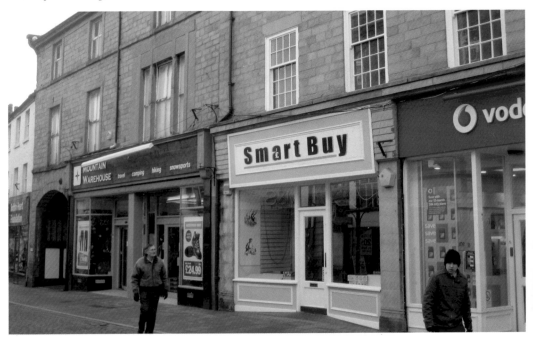

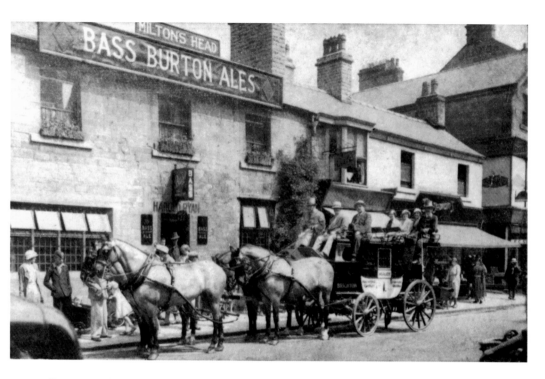

Miltons Head

This row of buildings is of early nineteenth-century origins and it has largely escaped the twentieth-century rebuilding of much of Spring Gardens. The upper photograph shows a 1930s horse-drawn excursion outside the Miltons Head, which appears largely unchanged today.

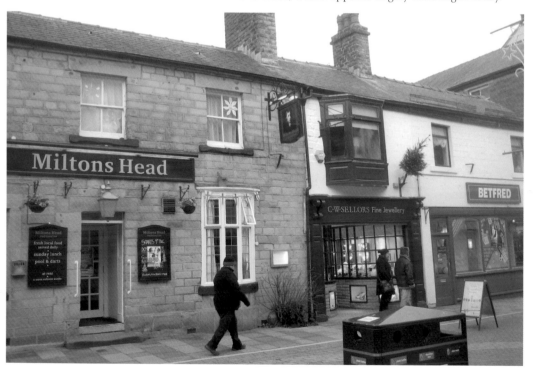

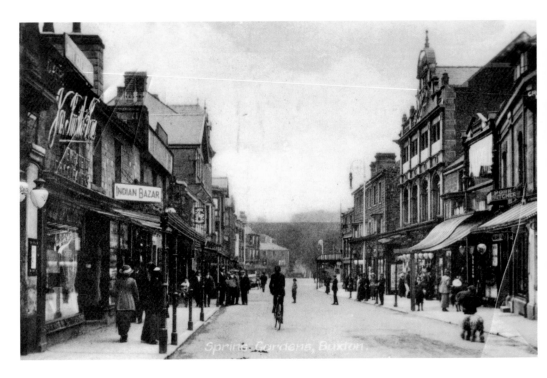

The Eastern End of Spring Gardens

At the eastern end of Spring Gardens several premises also had iron and glass colonnades. The shop with the prominent façade on the right is Boots the chemist. Beyond that is the Swedish Gymnasium, the elaborate three-storey building in iron and glass shown in the lower photograph, with an arcade of shops at street level.

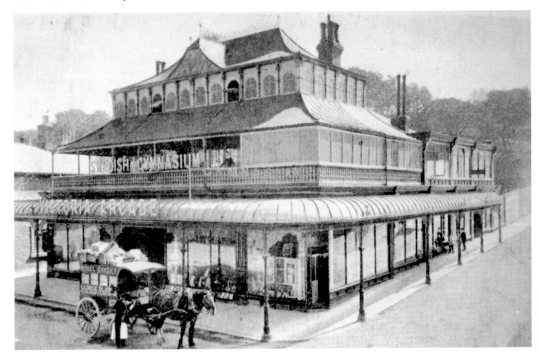

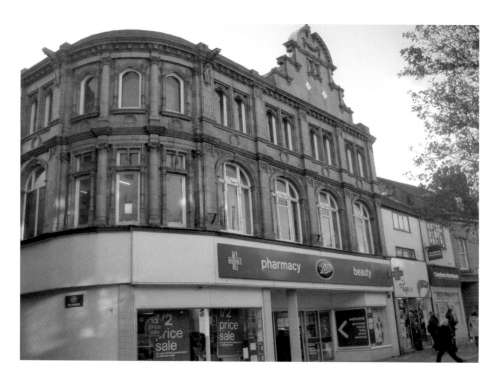

Boots the Chemist

These premises for Boots the chemist were built in a similar style to their headquarters in Nottingham. The interior of the shop was elegantly fitted out and had an imposing central staircase leading to an upstairs bookshop and library. Modernisation removed this attractive feature; the outside of the building remained the same except for the modern fascia.

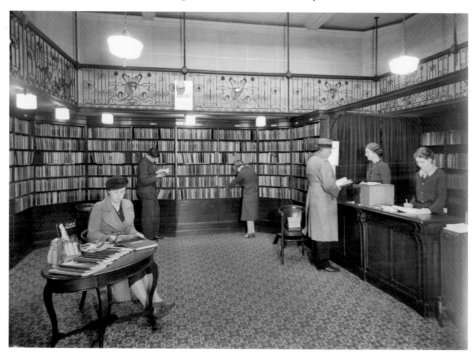

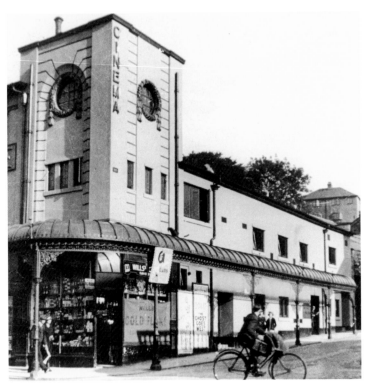

The Spa Cinema

The Swedish Gymnasium (Page 68) was demolished and replaced by a cinema, which opened in 1916 as the Picture House. This was rebuilt in 1937 and named the Spa Cinema. After a spell as a bingo hall in the 1980s, this building was also demolished. The present building on the site houses the Jobcentre, shown in the lower photograph.

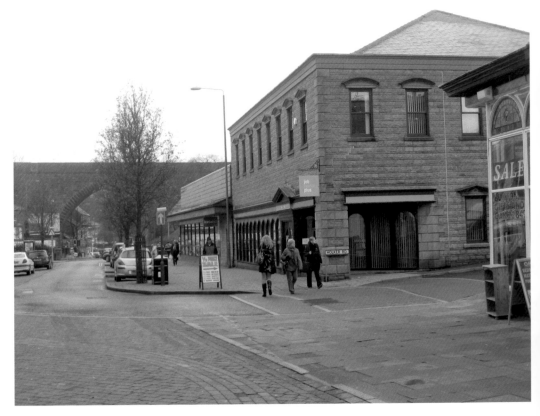

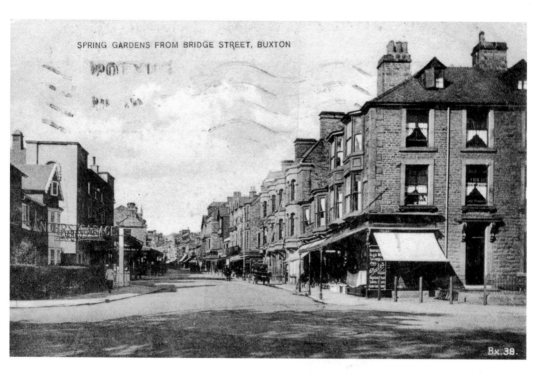

SPRING GARDENS FROM BRIDGE STREET, BUXTON

Bx.38.

Spring Gardens, East

The eastern end of Spring Gardens has seen other rebuilding. The Co-operative store on the right-hand side of the lower photograph was built in the 1930s, replacing the building shown in the upper photograph. The large building on the left in the upper photograph is the Spa Cinema, while in the lower photograph the Iceland store on that side has replaced a garage.

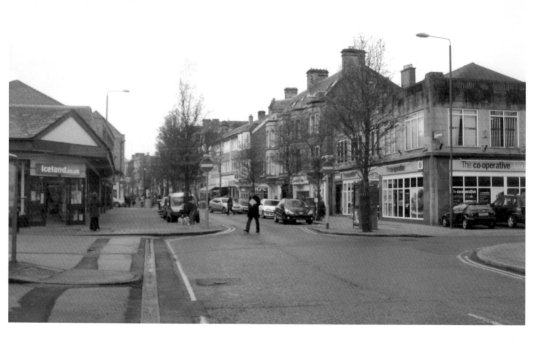

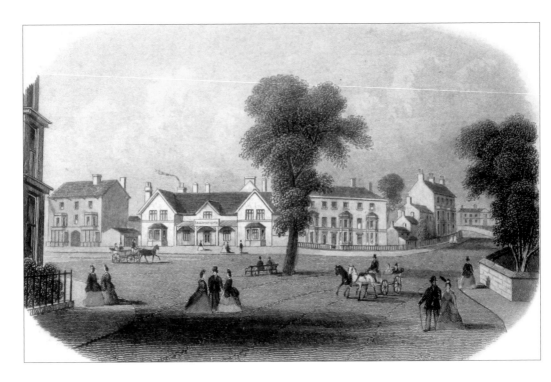

Railway Hotel

The two Buxton stations opened in 1863 and the Railway Hotel opened shortly afterwards in Bridge Street at the end of Spring Gardens. In 1901, a third line from the stations to Ashbourne was constructed, which required a large thirteen-arched viaduct across the Wye valley. This ran behind the Railway Hotel, as shown in the lower photograph. A more recent arrival is a hall of residence for the University of Derby, opened in 2007, which can be seen behind the viaduct.

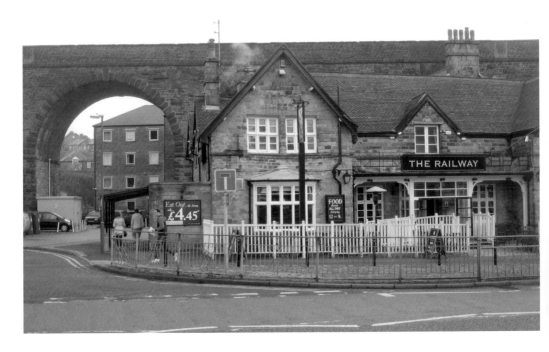

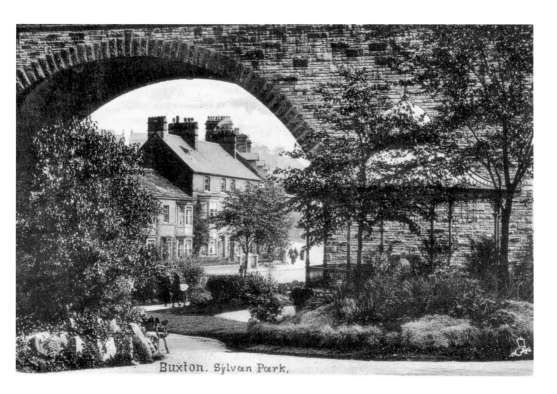

Buxton. Sylvan Park.

The Viaduct

On the right of the upper picture of page 72 a row of four buildings with descending roof lines can be seen. The smallest of these was demolished to make a route for the viaduct and Sylvan Park was established at the base of the viaduct. This area is now a car park and the halls of residence can be seen behind the row of buildings in the lower photograph.

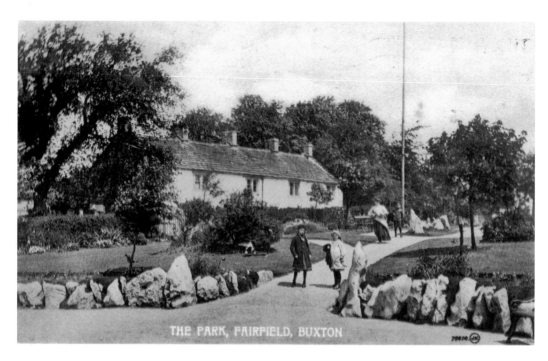

THE PARK, FAIRFIELD, BUXTON

Fairfield Village

The early settlement of Fairfield grew up around Fairfield church, about half a mile up the hill from the Wye valley, so that the two early settlements of Higher Buxton and Fairfield stood on the high ground on opposite sides of the valley. The cottages shown are adjacent to the church and the village spread out from there.

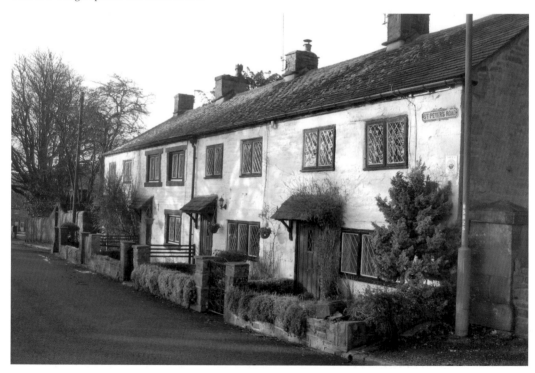

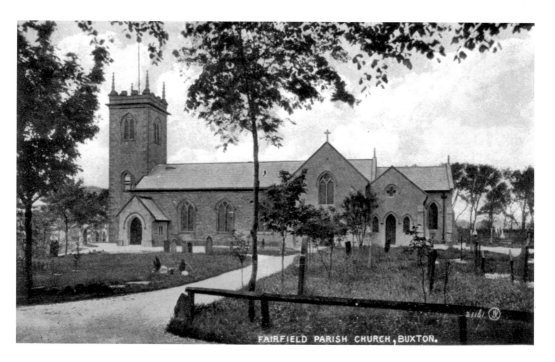

FAIRFIELD PARISH CHURCH, BUXTON.

Fairfield Church

In the Norman period, Fairfield was in the extensive parish of Hope, with Hope church about 8 miles away. A Chapel of Ease for the local villagers was established in the thirteenth century. After several centuries of mixed fortunes the chapel was demolished and the present church was built on the same site in 1839. The surrounding area had extensive grasslands in Green Fairfield. Fairfield and Buxton shared a medieval mill on the Wye in what is now Ashwood Park.

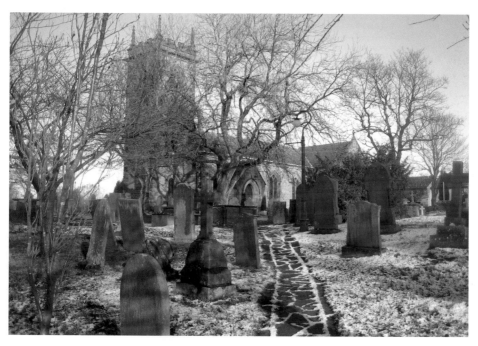

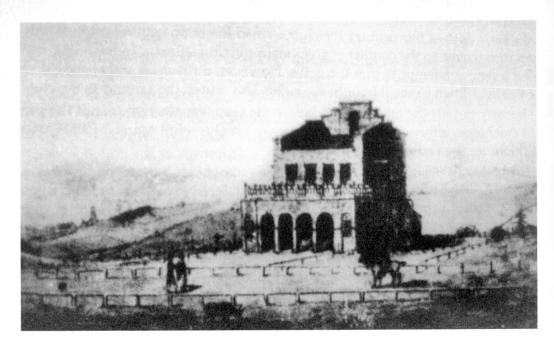

Fairfield Common

During the late eighteenth century, a racecourse was established on Fairfield Common and the Duke of Devonshire commissioned a grandstand for the racecourse (top photograph). The racecourse closed in 1840 and Fairfield Golf Course now extends across the common from its clubhouse on Waterswallows Road (lower photograph).

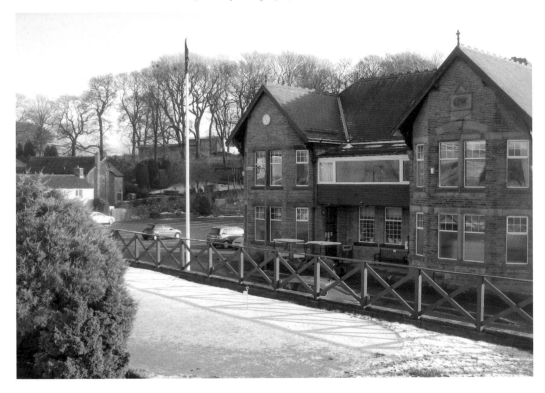

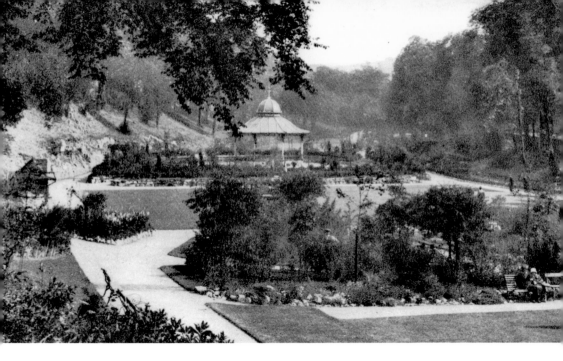

Ashwood Park

Just down from the viaduct shown on page 73, the Wye finally emerges from its subterranean transit of Buxton into Ashwood Park, which was laid out in the 1920s on the narrow strip of land between the road and the railway. Further along the park, the weir identifies the location of the former watermill that served Buxton and Fairfield for at least six centuries.

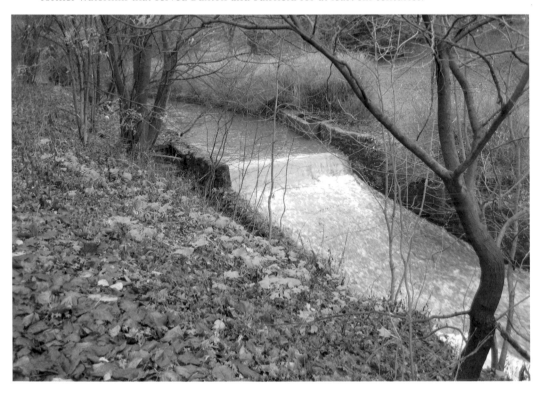

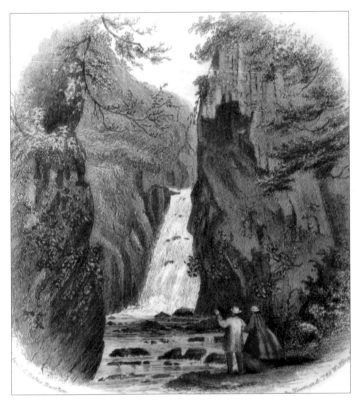

The Wye Valley

Continuing along the Wye from Ashwood Park takes one past Lovers Leap, a large cleft in the limestone rock where the Sherbrook joins the Wye This was a famous beauty spot in the nineteenth century but it is now somewhat overlooked because of the traffic along the adjacent A6 road.

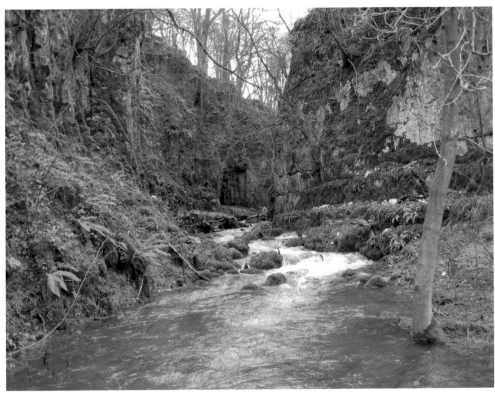

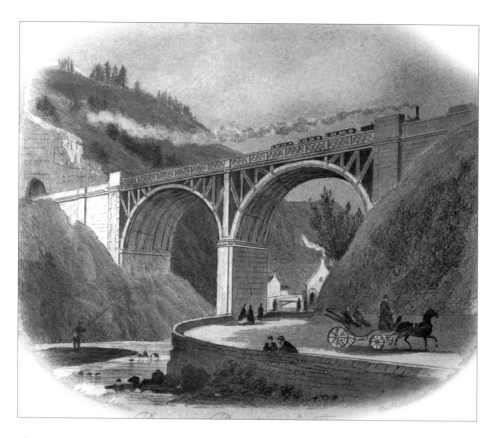

The Wye Valley

The traditional routes into Buxton came across the high ground but in 1810 a new route was created for the Duke of Devonshire along the narrow confines of the Wye valley (present A6 road), which linked Chatsworth and Buxton along a landscaped route. The railway link to London also came along the valley in 1863. This valley forms an important historic and scenic route to Buxton.

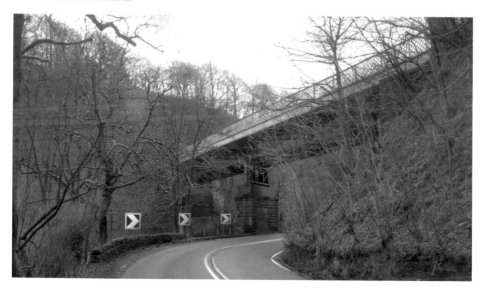

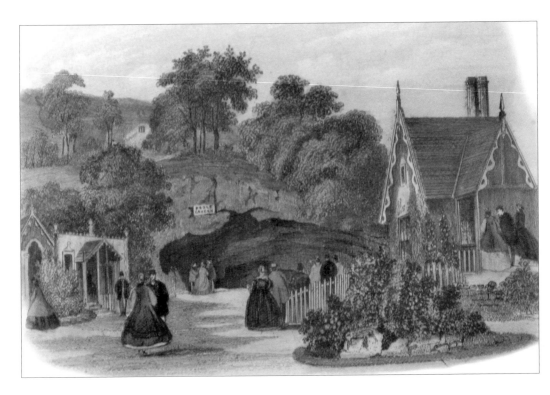

Poole's Cavern

Returning to the town centre and tracing the shorter branch of the Wye upstream from the large lake in the Pavilion Gardens leads to Wye Head where the river emerges from an underground section. This branch of the Wye goes underground on the south side of Grin Low and on its way to Wye Head passes through Poole's Cavern, a large natural cave with an easily accessible entrance.

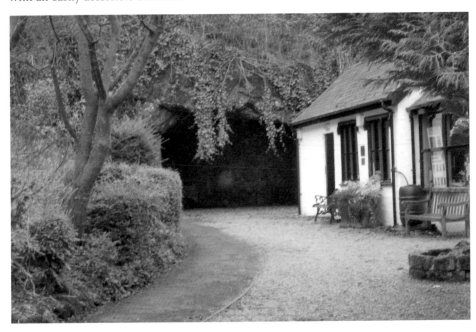

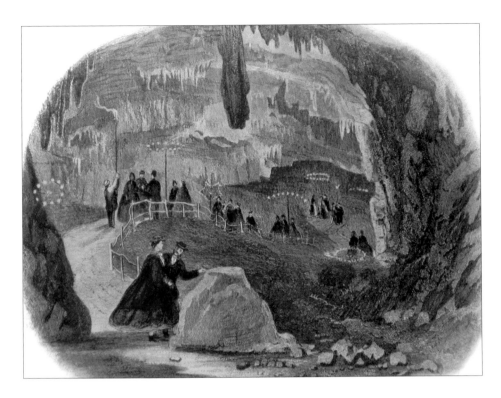

Poole's Cavern

The cave has been used over many centuries as a shelter or hiding place. In the mid-nineteenth century the cave was illuminated by gaslight and it became very popular with visitors. Modernised with electric lighting in the 1960s, it is now illuminated by up-to-the-minute LED lighting in a fascinating variety of colours. The cave has an impressive array of stalactites and stalagmites. There is a good interpretation display in the visitor centre.

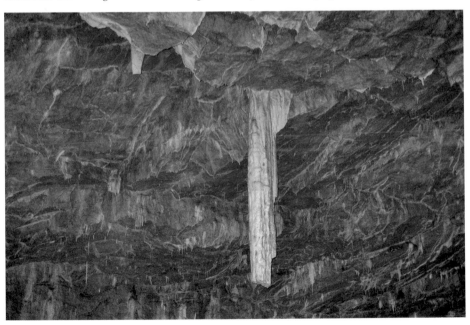

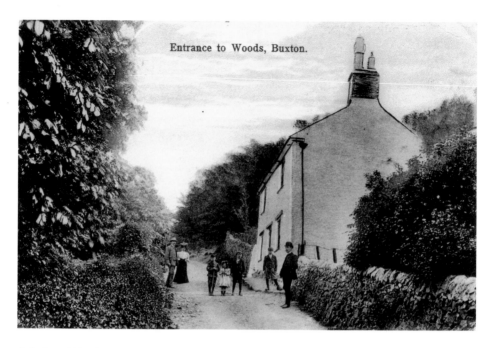

Entrance to Woods, Buxton.

Grin Low Woods

The hill known as Grin Low was covered by many small limestone quarries and lime kilns until the mid-nineteenth century when extensive tree planting took place. The woods are now popular for walking, with a wide range of trees and native plants. The woods form part of the Buxton Country Park and they have been designated a Site of Special Scientific Interest.

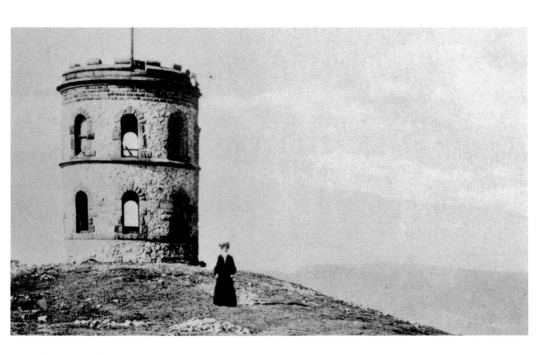

Solomon's Temple

Grin Low Tower was built by Solomon Mycock in 1896 and is generally known as Solomon's Temple. It stands on the highest point of Grin Low, at 1,434 feet, and has extensive views in all directions. The tower was built on an ancient burial mound and several Bronze Age skeletons and some Roman items were discovered when the tower was built.

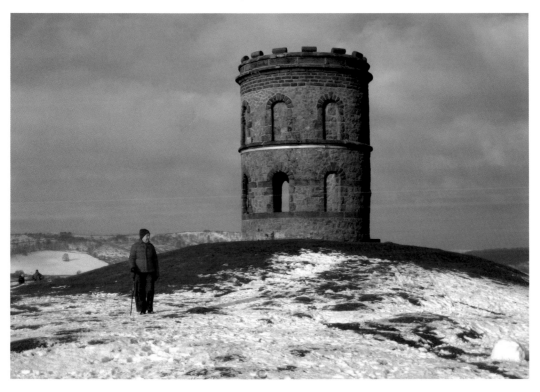

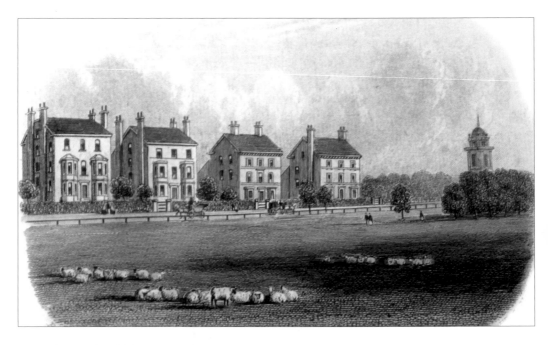

The Macclesfield New Road

In 1821, a new Buxton to Macclesfield road was built to replace the existing road, which had many severe gradients. This road began at St John's church and passed through the village of Burbage and across the hills on a more evenly graded route. The open area between the new road and the Manchester Road was developed as the Park, where a circular loop of road enclosed an area for a cricket ground, with four short access roads from the existing roads.

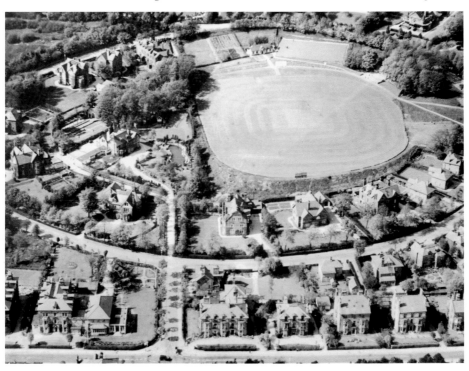

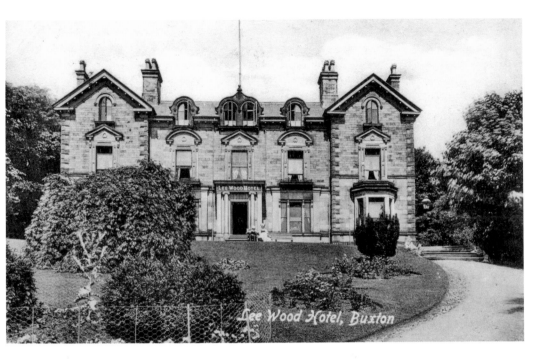

The Leewood Hotel

Large plots of land were set out for the construction of villas around the Park, which also attracted large hotels. The Leewood Hotel was built in on an imposing site at the Manchester Road side of The Park with extensive views across Buxton. The hotel remains a popular meeting place for local societies and festival events in addition to its residential business.

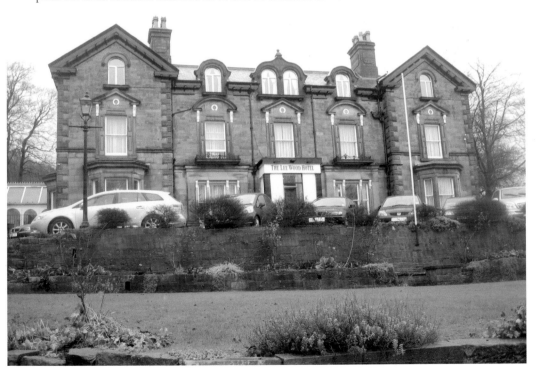

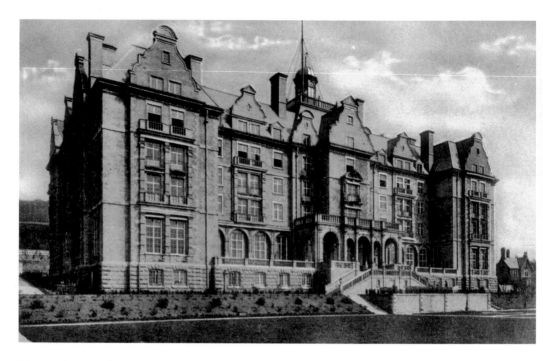

The Empire Hotel

The Empire Hotel was a large hotel on the Park which opened in 1903. It was used as part of a military hospital during the First World War and never reopened as a hotel. It was occupied by squatters after the Second World War and was demolished in 1964. Its impressive gateposts remain and the site is now used for apartments.

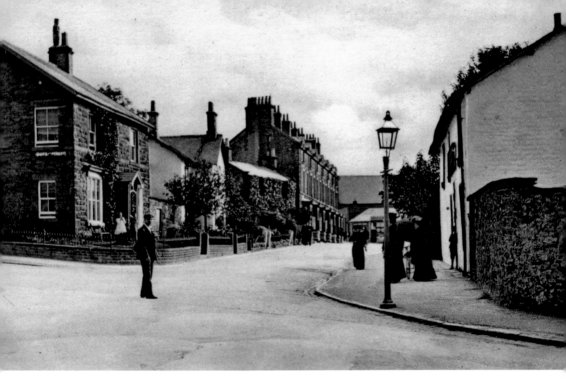

Burbage

The old and new Macclesfield Roads met at Burbage, then a separate village to the west of Buxton. In the upper photograph, the more distant buildings were a chapel and a row of small shops. As shown in the lower photograph, these have now been demolished, giving a view through to the hills beyond, and the site is awaiting redevelopment.

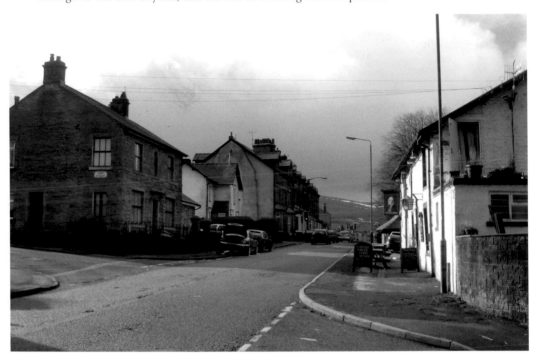

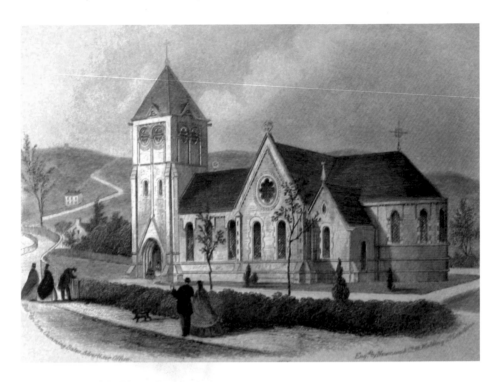

The Macclesfield Old Road

Burbage church stands at the intersection of the old and new roads to Macclesfield. The old road heads up hill past a former coal mining area. Although production from the mines was relatively small, it was important in providing fuel for the local lime burning industry on Grin Low and beyond. The road crosses the former route of the Cromford and High Peak Railway (CHPR) just above the former toll-house, seen on the right of the lower photograph.

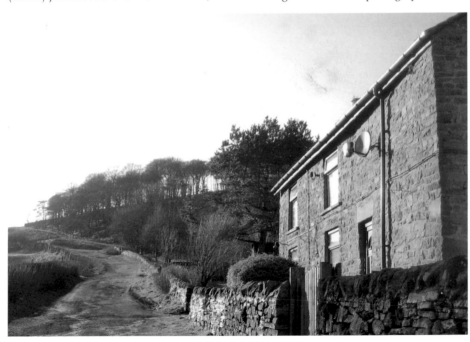

Coal Mines and the CHPR

The CHPR was a very early freight line (1831) that came past the Buxton coal mines and linked them to the local quarries. The lower photograph shows the CHPR embankment across the Wye and a siding to the mine. The upper photograph shows a small coal tip at the end of Level Lane, where a drainage level from the mine was also used to bring coal out of the mine by boat.]

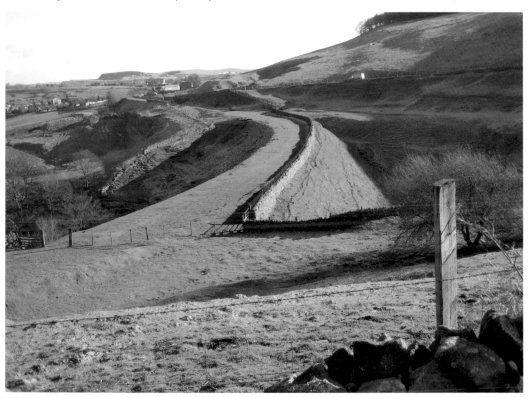

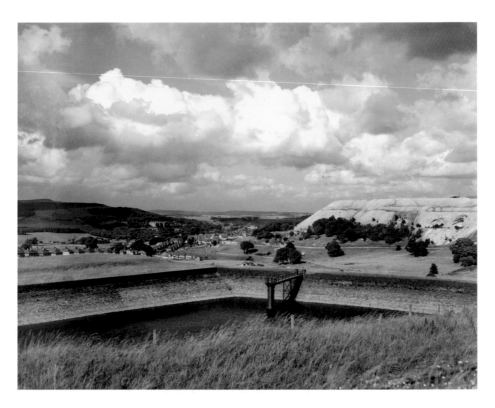

Views of Buxton and the CHPR

In the upper photograph, with Buxton in the distance, the 'white cliffs' on the right hand side are tips of waste material from Grin Low quarry. The lower photograph shows this area after a major reclamation and tree-planting project. Closer in, it also shows, from left to right, the old road, a track to the mine, the CHPR embankment and the Macclesfield New Road.

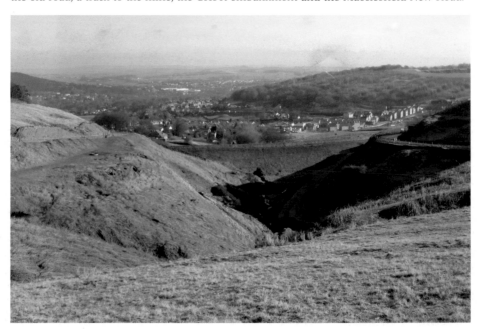

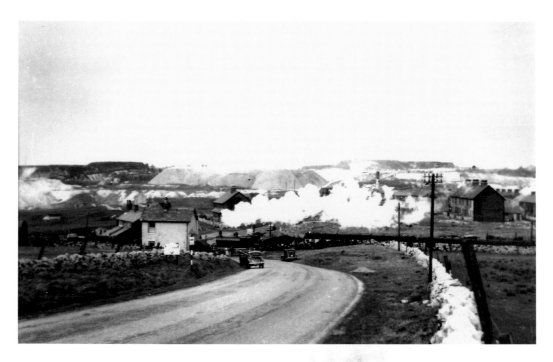

Ladmanlow and the CHPR

After 1892 the CHPR terminated at Ladmanlow, just up from Burbage. The upper photograph, taken in 1953, shows a goods train approaching the goods yard at Ladmanlow, past a level crossing. The tips from Grin Low quarry are also evident. In the lower photograph, the tips have been reclaimed and the area is tree covered while the level crossing and goods yard are no more.

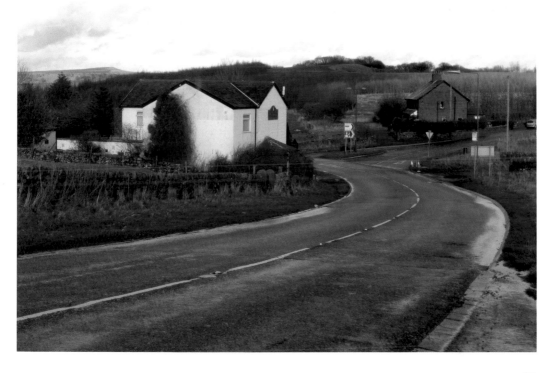

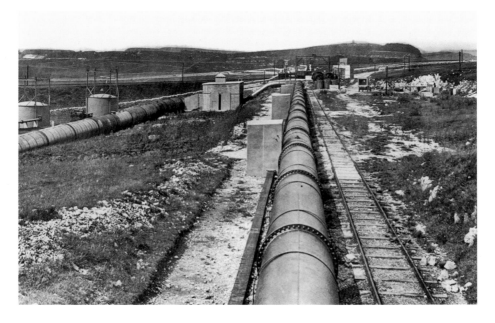

The Health and Safety Laboratory

In 1875, the CHPR abandoned a contour hugging stretch of their route by building massive embankments across a valley between Harpur Hill and Ladmanlow. In the 1920s, the Safety in Mines Research Board constructed a 1200 feet long gallery on an abandoned stretch of the CHPR track (upper photograph) for research into the control of coal dust explosions; this was superseded by a concrete gallery in the 1960s. The site became an internationally recognised centre of excellence across the range of fire and explosion problems in coal mining.

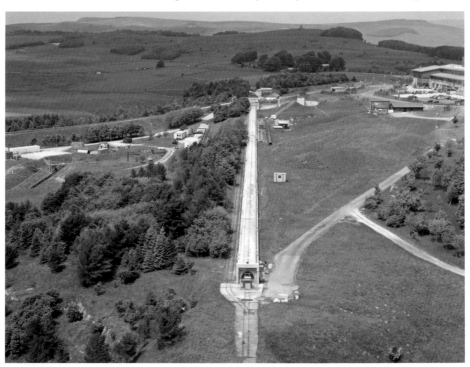

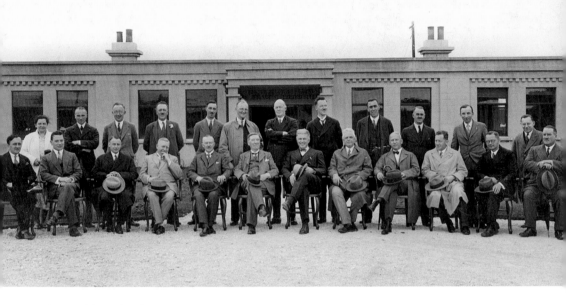

The Health and Safety Laboratory

The upper photograph shows the main building from the 1920s, with delegates to an international conference. After 1975, along with its linked laboratory in Sheffield, the role of the laboratory expanded to cover a wider range of occupational health and safety problems. In 2005, a purpose-built laboratory was opened at the Harpur Hill site (lower photograph). It housed some 300 research staff from both sites and its new facilities added further to the reputation of the laboratory.

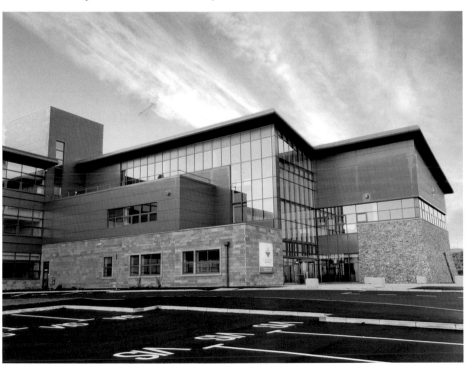

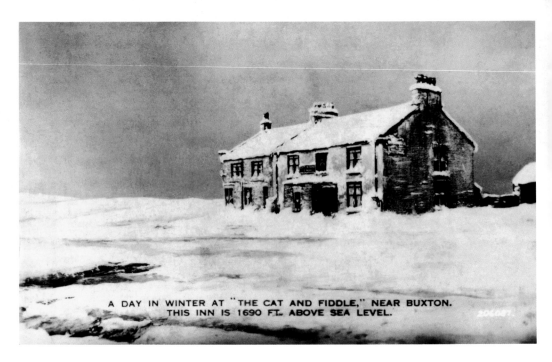

A DAY IN WINTER AT "THE CAT AND FIDDLE," NEAR BUXTON.
THIS INN IS 1690 FT. ABOVE SEA LEVEL.

Snow!

Buxton has a certain reputation for snowy conditions, particularly on the road to Macclesfield, past the Cat and Fiddle Inn at 1,690feet (upper photograph). However, there is enjoyment to be had from these snowfalls. The lower photograph shows a snow house built by railwaymen outside Buxton Station in 1898.

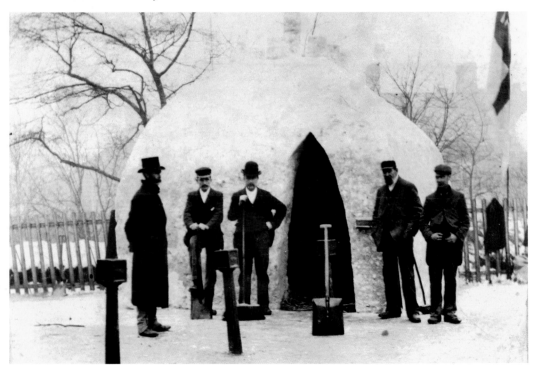

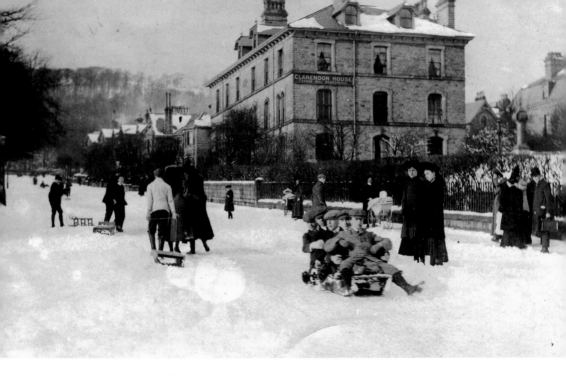

Snow!
Tobogganing is also enjoyed and on a clear winter's day, with sunshine overhead, the snow adds an alpine quality to familiar scenes!

Acknowledgements

In these acknowledgements, images are identified by a two-digit page number followed by 1 for the upper picture on the page and 2 for the lower picture on the page.

Picture the Past is a not-for-profit project that provides an archive of nearly 100,000 historic images from the library and museum collections across Derbyshire, Nottinghamshire, Derby and Nottingham. The archive can be searched free of charge at www.picturethepast.org.uk.

These images are courtesy of Buxton Museum and Art Gallery and Picture the Past: 10.1, 18.1, 35.1, 37.1, 43.1, 50.1, 51.1, 56.1, 60.1, 66.1, 69.1, 69.2, 84.2, 94.2.
These images are courtesy of the Board Collection and Picture the Past: 11.2, 33.1, 67.1, 68.1, 90.1.
These images are courtesy of Derbyshire Local Studies Library and Picture the Past: 13.1, 17.2, 19.1, 42.1, 42.2, 48.1, 60.2, 65.1, 94.1, front cover upper image, back cover upper image.
Image 61.1 is courtesy of Derbyshire Fire and Rescue Service and Picture the Past.
Image 22.1 is courtesy of D. D. Brumhead and Picture the Past.
Image 64.1 is courtesy of Miss Frances Webb and Picture the Past.
Image 49.1 is courtesy of Eric Dodman and Picture the Past.
Image 10.2 is courtesy of High Peak Borough Council.
Image 27.2 is courtesy of the University of Derby.
Images 31.2, 32.1, 32.2, 33.1, 33.2 are courtesy of the Buxton Opera House.
Images 23.2, 91.1 are copyright C. M. Bentley and J. M. Bentley, courtesy of J. M. Bentley.
Images 92.1, 92.2, 93.1, 93.2 are Crown Copyright, provided by the Health and Safety Laboratory.
Images 18.2, 19.2, 59.2 and front cover lower image are copyright D. Morten, courtesy of D. Morten.

I would also like to acknowledge valuable contributions and comments from Joanne Hibbert, David Morten and Kathy Roberts of the Buxton Group (www.buxton.group.co.uk).